NICOTEXT

THE 100 BEST AND ABSOLUTE GREATEST HEAVY METAL ALBUMS IN THE WORLD, EVER

Text: Jaclyn Bond

Photo:Tomas Eriksson/Studio Bildbolaget
tomas@bildbolaget
www.bildbolaget.se
Intern: Anna Skeppstedt

Copyright © NICOTEXT 2009 All rights reserved.
www.nicotext.com
info@nicotext.com

Printed in Poland
ISBN: 978-91-85869-65-7

FOREWORD

Heavy metal: a movement, a family, an intricate web of subgenres and disciplines all with their own unique and undeniable talents. Though popularly dismissed as insolent noise from society's anti-social fringe-dwellers, heavy metal is founded on one defining virtue: respect. From the scene's key players to its almighty army of fans, respect for talent and passion is what unites the masses. Tattoos won't get you in. Charisma alone won't cut it. Only a true metal heart will secure your place in this most loyal of families.

So what makes an album the best? Is it unparalleled musical wizardry? The impact it has on the genre in question? Record sales? One element that should be removed entirely from the equation is personal taste: whether I revel in or am repulsed by Cannibal Corpse does not play a part in this book. My definition of what makes an album great is based on the quality of the music, the quantity of people affected by it, and its influence on the heavy metal scene. You're not meant to love them all; the spirit of metal lies in diversity, debate, and passionate opinion. On the other hand, you may just cultivate a newfound adoration for doom metal, death 'n' roll or a good pig squeal.

A few bands have multiple album listings. Again, this is not a reflection of my obsession with Black Sabbath or Metallica, but rather recognition of musical careers spanning 30 or 40 years. To choose one album from twenty would be negligible if not impossible. The task of choosing the 100 greatest heavy metal albums was gruelling to say the least. The only way this book was made possible was with the help and wisdom of metal fans across the globe.

RAISE YOUR HORNS FOR:

Will Bond –the maharishi of music in all its guises. Expertise: Pantera, Sepultura.
Stephanie Convery –an inspired writer and musical sage. Expertise: Iron Maiden, Korn, Tool.
Jason Ellul –a heavy metal buff and literary talent. Expertise: System of a Down.
Tony Georgsson –a gifted writer moonlighting as the fifth member of Metallica. Expertise: Metallica.
David Johnson –a bona fide aficionado of all things metal. Expertise: Guns n Roses, Korn, Machine Head, Mayhem, Morbid Angel, Opeth, Type O Negative, Venom.
John Kenny –a genuine guitar-hero and all-round metal guru. Expertise: Post 1990 metal.
Duncan Legge –an erudite critic and metal authority; Expertise: Isis, Marilyn Manson, Meshuggah, Napalm Death.
Andy Neumann –a prolific writer with a true metal heart. Expertise: Meshuggah, Queensrÿche.
Mikael Persson –a connoisseur of the old-school scene who introduced me to metal, brought me to its birthplace and changed my life. Expertise: Pre 1990 metal.
Charith Sarathchandra –a talented writer, generous with both time and wisdom. Expertise: Slayer.

INDEX

ACCEPT
BALLS TO THE WALL
1983 (GERMANY) 1984 (USA)

With a title and cover art that could be mistaken for a gay porn film, Accept's *Balls to the Wall* was bound to raise an eyebrow or two. A "gay metal" hoopla erupted upon the album's US release, with tracks such as *London Leatherboys* and *Love Child* the focus of intense scrutiny. Guitarist Wolf Hoffman was later quoted as saying "You Americans are so uptight about this. In Europe it was never a big deal...we just wanted to be controversial and different and touch on these touchy subjects, because it gave us good press and it worked fabulously, you know".

Conceptually different to their previous work, though still keeping in line with the band's sociopolitical bent, *Balls to the Wall* became Accept's highest selling and best-known album. The smooth production, fierce riffs and solid melodies behind Udo Dirkschneider's grating vocals have created a stock of pure metal classics. Largely considered one of the greatest metal albums of the 80s, *Balls to the Wall* is 45 minutes of unadulterated, anthemic, heavy metal fun.

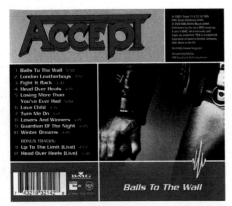

And then some:
- The title track *Balls to the Wall* was featured on the 1993 *Beavis and Butthead* episode *Tornado, Guitar Hero Encore: Rocks the 80s, Grand Theft Auto: Vice City Stories* as well as various metal lists.
- The character Dark Schneider in the Japanese manga and anime series *Bastard!!* is named after singer Udo Dirkschneider.
- Guitarist Wolf Hoffman loved photography as a hobby (he took the cover photo for Objection Overruled) and eventually made it his career following Accept's official retirement in 1996.

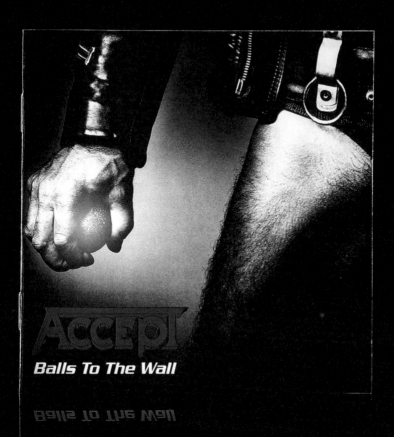

Accept

Balls To The Wall

Also by Accept:
If you rate *Balls to the Wall*, check out *Restless and Wild* (1982) and *Metal Heart* (1985): classic metal.

AC/DC
HIGHWAY TO HELL
1979

Though AC/DC may not cut it in today's brutal death loving, corpse licking, humanity hating black metal genre, they have all the elements of a bona fide metal band. Lead singer Bon Scott choked to death on his own vomit after drinking himself into oblivion. His replacement Brian Johnson sang the lyrics "have a drink on me" in the follow up album *Back in Black* without a lick of shame. And with *Highway to Hell*, AC/DC were labelled Satanists and were blamed for inciting the brutal murders committed by an AC/DC fan under the influence of the infectious grooves in *Night Prowler*.

Highway to Hell has the one thing *Back in Black* doesn't have: Bon Scott. Scott's signature pounding vocals are backed up by tight harmonies, Phil Rudd's vicious kick drum and a new approach to production at the hands of Robert John "Mutt" Lange. The tracks are neat and compact, simple hook-heavy classics. The title cut is easily one of the greatest songs of all time, Touch Too Much is a hilarious almost punky highlight of the album, and Girls got rhythm has some of the catchiest riffs going.

And then some:
- *Highway to Hell* is AC/DC's 6th studio album and Bon Scott's last hurrah. His final words on the album are "shazbot, nanoo, nanoo".
- Richard Ramírez, nicknamed the "Night Stalker" committed several brutal murders in Los Angeles in 1985. Police claimed that Ramirez was wearing an AC/DC shirt and left an AC/DC hat at one of the crime scenes. It's been said that Ramirez was inspired by the song *Night Prowler*.
- *Highway to Hell* has been covered by Quiet Riot, Billy Joel, Marilyn Manson and Maroon 5 among many others.
- When accused of Satanism, Malcom Young denied the claim with the words: "me mum would kill me for that!"

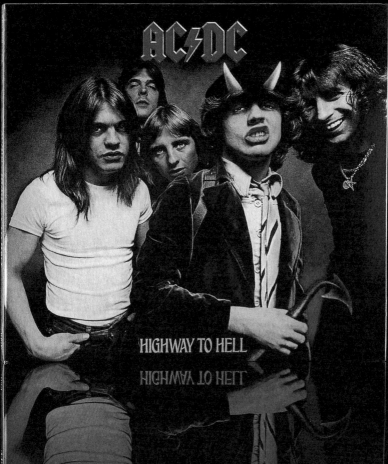

AC/DC

HIGHWAY TO HELL

1. HIGHWAY TO HELL
2. GIRLS GOT RHYTHM
3. WALK ALL OVER YOU
4. TOUCH TOO MUCH
5. BEATING AROUND THE BUSH
6. SHOT DOWN IN FLAMES
7. GET IT HOT
8. IF YOU WANT BLOOD (YOU'VE GOT IT)
9. LOVE HUNGRY MAN
10. NIGHT PROWLER

Also by AC/DC:
You can't go past *High Voltage* (1976) or *TNT* (1975) for a crash course in early Australian metal genius.

ΛC/DC
BACK IN BLACK
1980

1980: A leap year starting on a Tuesday. John Lennon dies, Iron Maiden explodes onto the scene, and AC/DC release one of the most superlative albums of all time. *Back in Black* delivers track after track of relentless, vein-popping power –a fitting tribute to the beloved Bon Scott whose "death by misadventure" a mere 5 months before the album's release caused fleeting thoughts of disbandment. Brian Johnson was chosen to step into Scott's sacred spray-on pants, bringing with him an intensity so great he could make the lyrics *Cause I'm back/ Yes, I'm back/ Well, I'm back/ Yes, I'm back/* sound like a magnum opus.

By 2003, *Back in Black* had sold 42 million copies worldwide, making it the best selling album ever released by a band. The title track (co-written by brothers Malcolm and Angus Young) went gold then platinum and topped charts around the globe. To this day, the song's killer opening riff is abused and defiled worldwide by artists such as the Beastie Boys, Eminem and Shakira. Doesn't get much more brutal than that. If you appreciate simple composition, throat-ripping vocals, thumping chords and lashing drums: get this.

And then some:
• The only album to outsell *Back in Black* is Michael Jackson's Thriller.

• In his audition to replace Bon Scott, Brian Johnson impressed the band with his amped-up version of Ike and Tina Turner's *Nutbush City Limits*.

• The name AC/DC is taken from the abbreviation for alternating current/direct current that the Young brothers saw on the back of their sister's sewing machine.

• Before settling on his iconic school uniform, Angus tried out other costumes such as Spider Man, Zorro, and a gorilla suit.

Also by AC/DC:
Check out the band's cracking discography and you'll find absolute classics like *Let There Be Rock* (1977) and *Highway to Hell* (1979).

ALICE COOPER
BILLION DOLLAR BABIES
1973

I often think of Alice Cooper as a zany balloon-twisting clown. Bare with me here: the makeup, the wildly unkempt eyebrows, the endless desire to entertain despite any cost to self-respect or pride. He took the comparatively inoffensive genre of rock 'n' roll and twisted, shaped and mangled until he'd transformed it into a different beast altogether...a heavy, metallic, shock-rock hybrid. With this new sound, Alice and his band led children astray like a menacing pied piper and garnered just the right amount of media-attracting hostility from their parents.

Billion Dollar Babies is hands down, the best Alice Cooper album ever released. It features the AC dream team of Cooper, Buxton, Bruce, Dunaway and Smith. It also features 10 of the most iconic songs in music history. The musicianship is tight and punchy, the production is immaculate and the lyrics...oh the lyrics. *"Ready as this audience that's coming here to dream / Loving every second, every moment, every scream"* – can you imagine hearing those words emanating from a man dressed in an androgynous witch costume? How about if said witch was simultaneously being decapitated, electrocuted or mauled by a boa constrictor? No one does nightmare meets vaudeville like Alice Cooper. *Billion Dollar Babies* is best played at ear-splitting volume, preferably in a basement with pilfered booze in hand. Fantastically old-school.

And then some:
• The original vinyl release of *Billion Dollar Babies* came with a billion dollar note featuring the band on the front and a political cartoon on the back.

• Megadeth covered *No More Mr. Nice Guy* for the movie *Shocker*.

Also by Alice Cooper:
To state the blaringly obvious, *School's Out*
(1972) is worth every penny.

ALICE IN CHAINS
DIRT
1992

Alice in Chains have defied classification since their inception in 1987. The heaviest of the Seattle grunge scene, the softest of the metal world, they've been booed off stage and hailed as gods by genre purists worldwide. Whatever your persuasion, it cannot be denied that *Dirt* is one of the most brutal albums ever made. Violently honest and devastatingly bleak, *Dirt's* central focus is on the cruel succubus that is heroin addiction. Vocalist Layne Staley's rampant drug dependence strangulated the band from around 1990 until the singer's death in 2002. It weighed so heavily on the band, infiltrating every creative orifice that their only choice was to explore it in their second album.

Guitarist Jerry Cantrell penned most of the tracks on Dirt, exorcising his demons in every wretched line. At times acoustically gloomy, often desperate as a racing pulse –the album is a depressing, harrowing journey. Though not every track is centred on addiction (Rooster details the tormented life of a soldier), the darkness permeates every riff, every beat, every moody bass line. Be it a shot at redemption or a primal, stomach-churning screech for help, Dirt is a trip worth taking.

And then some:

• Metallica, Monster Magnet, Godsmack and Kyuss among many others name Alice In Chains as a defining influence.

• Alice In Chains contributed the song *Would?* to Cameron Crowe's 1992 romantic comedy film *Singles*.

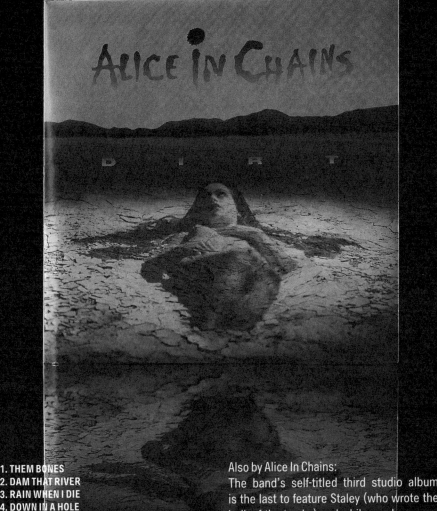

Also by Alice In Chains:
The band's self-titled third studio album is the last to feature Staley (who wrote the bulk of the tracks) and while nowhere near the magic of *Dirt*, is definitely worth a listen.

ALL SHALL PERISH
THE PRICE OF EXISTENCE
2006

Breakdown after savage breakdown, blastbeat after devastating gravity roll, the price of existence is apparently unbridled fury. The Californian deathcore quintet show expert musicianship and masterful song craft in their second studio album. Though repetitive to a degree and somewhat lacking in bass, All Shall Perish unleash 43 minutes of savage, genre-hopping aggression. With only one track (*Greyson*) offering any respite from the carnage, *The Price of Existence* leaves no room for pathetic wailing or moody interludes.

Lyrically, the album focuses on the socio-political climate of the world at large, the environmental devastation wreaked by a selfish society and the despicable amoral actions of the corporate world. Vocally, it really doesn't matter. Hernan Hermida's sickening, guttural roar renders even the most eloquent lyric indecipherable. Equally competent in death-knell growls and banshee-esque pig squeals, Hermida has most definitely found his calling. Ben Orum and Chris Storey's twin guitar harmonies create intricate tremolo lines relentlessly driven onward by Matt Kuykendall's inexorable triplets and insane fills. It's Metal 101 with a chugging major.

And then some:
- In September 2008, All Shall Perish became the first all-American metal band to tour Siberia.
- The title of the 4th track on the album is taken from a quote by environmentalist David Bower.
- The band encourages fans to call and leave jokes on their collective answering machine. The funniest caller can win an All Shall Perish t-shirt. Brutal right?

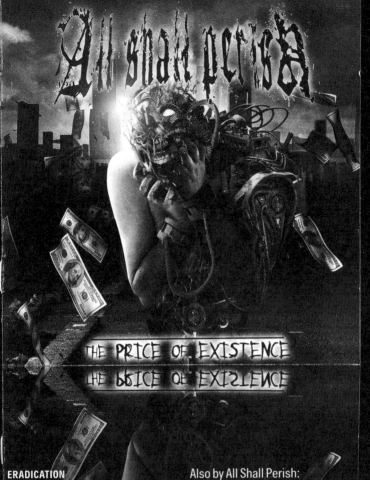

All Shall Perish

THE PRICE OF EXISTENCE

ERADICATION
WAGE SLAVES
THE DAY OF JUSTICE
THERE IS NO BUSINESS TO BE DONE ON A
DEAD PLANET
BETTER LIVING THROUGH CATASTROPHE
PRISONER OF WAR
GREYSON
WE HOLD THESE TRUTHS....
THE TRUE BEAST
PROMISES
THE LAST RELAPSE

Also by All Shall Perish:

The band only has three studio albums in their discography to date. Their 2008 release *Awaken the Dreamers* won't taint your collection in any way.

ANTHRAX
AMONG THE LIVING
1987

The thrash metal scene of the 80s was dominated by the Big Four: Slayer, Metallica, Megadeth and Anthrax. Hailing from America's East Coast, Anthrax expanded the genre with their heavy sound strongly influenced by the New York hardcore punk scene. Joey Belladonna's clear cutting vocals, Charlie Benante's furious drums and the band's shouting refrains both won them fans and ostracised them from the Big Four in the minds of thrash metal purists. Anthrax didn't seem to mind at all. The band's third studio album earned international acclaim and a gold certification by the RIAA. Arse-kicking anthems like I am the Law and Caught in a Mosh saved the 80s from hair metal and created an army of devotees.

Far from the brutal realities of drug addiction, suicide or other tried and true themes explored in metal lyrics, Among the Living is inspired by Stephen King novels and comic book characters. Pure adrenalin pulses through this entire album, urging the listener on (almost to the point of annoyance) before justifying the intensity with clever musicianship and inspired lyrics.

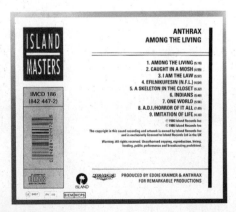

And then some:
- Anthrax dedicated Among the Living to former Metallica bassist Cliff Burton.
- Efilnikufesin is actually "nise fuckin' life" spelled backwards. The song was based on the life of American actor, comedian and musician: John Belushi.

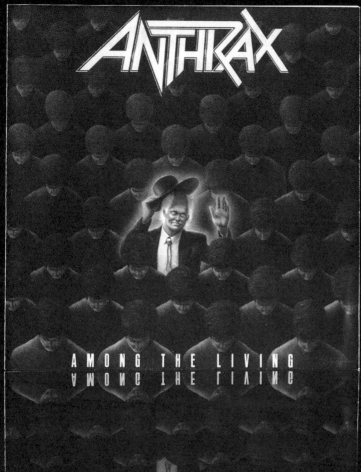

AMONG THE LIVING

Also by Anthrax:
The band's sixth studio album, *Sound Of White Noise* (1993), marked a change of direction for the Anthrax. It was their last album with guitarist Dan Spitz and their first with former Armoured Saint vocalist John Bush. Look this one up.

ARCH ENEMY
BURNING BRIDGES
1999

Burning Bridges incorporates the best elements of melo-death gods Dark Tranquillity and In Flames and adds depth, moodiness and quality songwriting. The Amott brothers' stirring harmonies, dual guitar riffs and massive hooks drag this album out of the monotony of simple melodic death metal to produce the band's best ever album and one of the greatest examples of the genre. It's the last album to feature Arch Enemy's ultimate line up with Johan Liiva on vocals and Christopher Amott adding stabilising leads to his brother's insane wah pedal phrasing. Liiva was later replaced with German vocalist Angela Gossow.

From the opening riff of Immortal, it's clear the band hail from the upper echelons of metal musical mastery. Daniel Erlandsson's thunderous drums and Sharlee d'Angelo's heavy rhythm bass take the Amott brothers' numerous solos to a level of superb craftsmanship as opposed to arrogant wankery. Technically splendid and catchy as hell, Burning Bridges proves that intelligent musicianship and melodic brutality are not mutually exclusive.

And then some:
• Johan Liiva was asked to leave the band in November 2002. According to Liiva, he received a letter from Michael Amott saying that Arch Enemy would be auditioning a new singer and that he should pursue other projects.
• Angela Gossow gave Michael Amott her demo tape while interviewing him for a German webzine.
• Ibanez now produces the Sharlee d'Angelo signature bass, called the SDB1, which is tuned to Sharlee's preferred C standard (low to high - C,F,Bb,Eb).
• Michael Amott and Angela Gossow lend their voices to Adult Swim's brilliant animated series Metalocalypse.

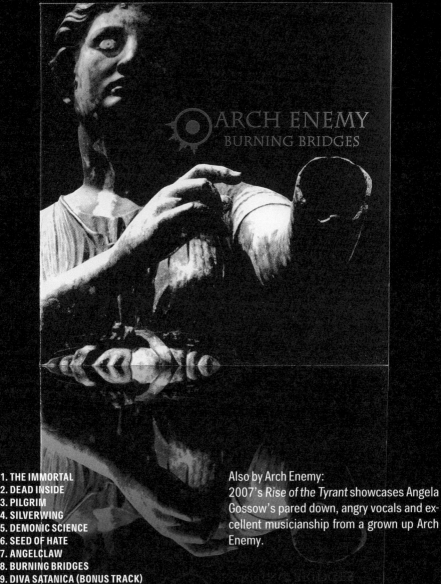

ARCH ENEMY
BURNING BRIDGES

1. THE IMMORTAL
2. DEAD INSIDE
3. PILGRIM
4. SILVERWING
5. DEMONIC SCIENCE
6. SEED OF HATE
7. ANGELCLAW
8. BURNING BRIDGES
9. DIVA SATANICA (BONUS TRACK)
10. HYDRA (BONUS TRACK, INSTRUMENTAL)

Also by Arch Enemy:
2007's *Rise of the Tyrant* showcases Angela Gossow's pared down, angry vocals and excellent musicianship from a grown up Arch Enemy.

AT THE GATES
SLAUGHTER OF THE SOUL
1995

Another offering from Sweden's apparently bottomless pit of metal genius, At the Gates revolutionised the scene and made the melodic death genre what it is today. Though it marked the termination of one of the greatest metal bands in history, *Slaughter of the Soul* remains the most influential melodic death album of all time. It paved the way for nu metal and metalcore among other genres and has inspired a plethora of copycat bands. To this day, the album is the ultimate example of pure melodic death metal.

Part of Gothenburg's Holy Trinity (along with Dark Tranquillity and In Flames), At the Gates are counted among the forefathers of the Gothenburg sound. This album proves why. Each song is ridiculously catchy and furiously infectious. Heavy writing, tight arrangements, razor-sharp twin guitar shredding...the ultimate stage is set for Thomas Lindberg's vocals. His screams are sheer agony, his passion complete and intrusive. The short heavy intros, fast moving riffs and intelligent production (that allows breathing space to bolster unpretentious musicianship) make this album unfailingly accessible. If you're still undecided, a listen to Andy LaRocque's guitar solo on the standout track *Cold* should set you straight. Not there yet? Check out track 4, *Under the Serpent Sun*. If you can't get into that, you're just not metal.

And then some:

• The 2002 re-release of *Slaughter of the Soul* features six bonus tracks including Slaughter Lord, Slayer and No Security covers.

• Since disbanding, members of ATG have gone on to create The Haunted, Cradle of Filth and Crown (among others) between them.

• Peaceville Records released an At the Gates retrospective in 2001 titled *Suicidal Final Art*.

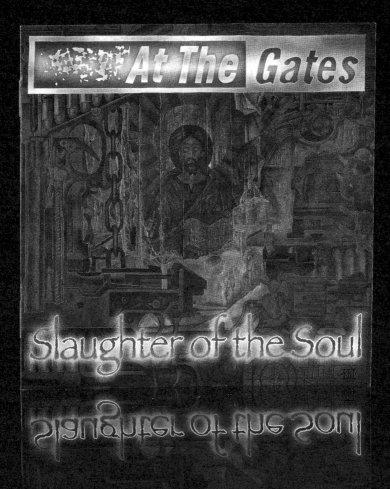

1. BLINDED BY FEAR
2. SLAUGHTER OF THE SOUL
3. COLD
4. UNDER A SERPENT SUN
5. INTO THE DEAD SKY
6. SUICIDE NATION
7. WORLD OF LIES
8. UNTO OTHERS
9. NAUSEA
10. NEED
11. THE FLAMES OF THE END

Also by At the Gates:
Terminal Spirit Deceased is another killer ATG album.

BEHEMOTH
DEMIGOD
2004

Demigod is the seventh studio album from Polish blackened death metal band Behemoth. As a follow up to 2002's well-received *Zos Kia Cultus*, fans expected something special. No one expected the absolute bludgeoning delivered on *Demigod*. Eastern/Egyptian influences and carefully placed acoustic guitar solos give the entire album an ethereal, almost creepy feel. Horns are used, Eastern guitar scales, melancholic wailing...but don't let this or the long moody intro fool you into thinking this album is in any way soft. What follows is a 40-minute punch to the guts.

Demigod is intensely aggressive, almost to the point of being frightening. Negal's layered vocals are uncompromisingly nasty. The guitars are thick and chunky and Inferno's drums are just ridiculously good (without engulfing the band completely). Production is tight, steering the band well away from the typical death metal messy-wall-of-sound phenomenon. Every element is audible and decipherable while still being insanely brutal. Through years of line-up and sound changes Behemoth found their feet on this, their most acerbic offering.

And then some:

• Nile guitarist Karl Sanders plays an impressive solo on track 8: XUL.

• Behemoth is named on a list of bands that allegedly promote Satanism and murder. The list was given to Polish officials by the Committee for Defence Against Sects in the hope of banning such music in Poland.

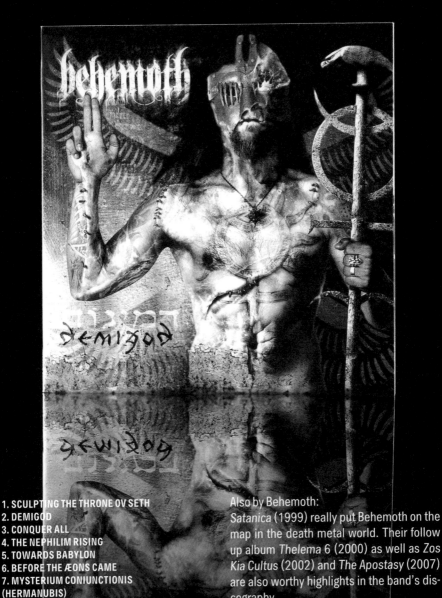

Also by Behemoth:
Satanica (1999) really put Behemoth on the map in the death metal world. Their follow up album *Thelema 6* (2000) as well as *Zos Kia Cultus* (2002) and *The Apostasy* (2007) are also worthy highlights in the band's discography.

BENIGHTED

ICON

2007

Icon is Benighted's fifth studio album. "Fifth?" you may exclaim, "there are more of these?" Benighted are death metal's best kept secret or most underrated talent, however you want to look at it. Why? Possibly because they're French, probably due to poor promotion and a tight-lipped fan base. Either way, Benighted are the epitome of ultra brutal death metal –the heaviest band you never knew.

Icon –though not as technical as the band's previous offering Identistick– is brilliantly creative in its brutality. Interesting song structures incorporate groove and grindcore elements into some of the most vicious death metal around today. The aural annihilation is tempered with the odd melodic reprieve to create a balanced, calculated chaos. Julien Truchan's volatile, erratic vocals span an impressive range of death-knell shrieks and growls. His ferocity imbues the entire album with a kind of unhinged, maniacal fever that both captivates and assaults the listener. Blastbeats, double bass, heavy guitars...this album takes all the usual death metal ingredients and manages to create, through some clever slight of hand, something innovative enough to shove the entire genre forward into unchartered territory (note the experimental "rap" in track 3: *Grind Wit*).

1. Complete Exsanguination
2. Slut
3. Grind Wit
4. Say It All
5. Forsaken
6. Smile Then Bleed
7. Pledge Of Retaliation
8. Icon
9. Human Circles
10. Invigilate
11. The Underneath
12. Blindfolded Centuries

www.osmoseproductions.com

And then some:
• *Icon* is an acronym for Infinitive Conscience Of Nothingness.
• Benighted's main influences include Cannibal Corpse and Marduk.

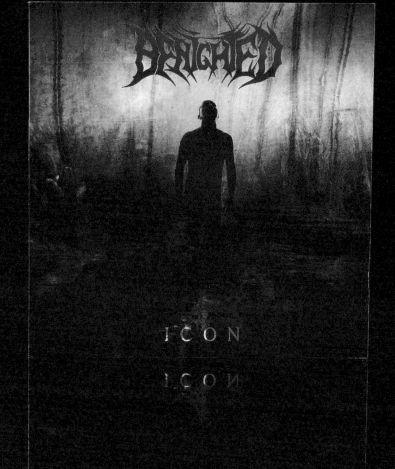

BENIGHTED

ICON

Also by Benighted:
Acquaint yourself with Benighted's unquestionable talent with *Insane Cephalic Production* (2004) and *Identistick* (2007), which features a nice cover of Napalm Death's *Suffer the Children*.

BLACK LABEL SOCIETY
HANGOVER MUSIC VOLUME VI
2004

Zakk Wylde: guitar hero, Hollywood Rock Walk of Famer, keeper of The (Holy) Grail. Add to that songwriter, producer, vocalist, pianist...God? *Hangover Music Volume VI* is a veritable showcase of Wylde's innumerable talents. Though some may say the album is a step away from BLS' true purpose, a flip through the band's catalogue (pay special attention to *Dead Meadow* on 2003's *The Blessed Hellride*) will reveal this album's slow but steady journey.

Though penned to fulfil a contractual obligation to record company Spitfire, *Hangover Music* is loaded with soul. The presence of pianos and acoustic guitars may challenge fans of BLS' signature speed metal aggressiveness, but make no mistake: this is Black Label Society's heaviest album to date. Emotionally draining, depressing and moody, the album focuses on the themes of drug addiction, abuse, grief and loss. Elements of doom and stoner rock (note track 8: *House of Doom*) along with passionate solos and moving lyrics really do make this the perfect hangover music. If there is any shred of optimism left in you at the midway point in the album, the tribute to Alice in Chains' deceased frontman Lane Staley should bring it home. If not, the pure piano cover of Procol Harum's *Whiter Shade of Pale* will bring a tidal wave of anguish and sorrow. It's tough going, but worth every ounce of pain.

1. crazy or high
2. queen of sorrow
3. steppin stone
4. yesterday, today, tomorrow
5. takillya (estyabon)
6. won't find it here
7. she deserves a free ride (val's song)
8. house of doom
9. damage is done
10. layne
11. woman don't cry
12. no other
13. whiter shade of pale
14. once more
15. fear

produced by - zakk wylde
associate producer - barry connley

And then some:
- BLS has never performed any of the songs on Hangover Music live.
- Zakk Wylde played every instrument except for drums on BLS' first four albums.
- Wylde's signature Les Paul guitar known as "The Grail" was once lost during transportation between gigs. Rewards were offered and the guitar was eventually returned after a fan bought it at a pawnshop and noticed the initials Z.W engraved into the Humbucker pickups.

black label society
hangover music

vol. VI

1. CRAZY OR HIGH
2. QUEEN OF SORROW
3. STEPPIN' STONE
4. YESTERDAY, TODAY, TOMORROW
5. TAKILLYA (ESTYABON)
6. WON'T FIND IT HERE
7. SHE DESERVES A FREE RIDE (VAL'S SONG)
8. HOUSE OF DOOM
9. DAMAGE IS DONE

10. LAYNE
11. WOMAN DON'T CRY
12. NO OTHER
13. A WHITER SHADE OF PALE
(PROCOL HARUM COVER)
14. ONCE MORE
15. FEAR

Also by Black Label Society:
The Blessed Hellride (2003) and *Mafia* (2005) are both excellent. Also check out Zakk Wylde's solo effort *Book of Shadows* (1996) for another dose of introspective gloom.

BLACK SABBATH

BLACK SABBATH
1970

Cream, Blue Cheer, Zeppelin, Vanilla Fudge...I hear you. Pioneers without a doubt, geniuses in their own right, groundbreaking one and all. But Sabbath, oh Sabbath. To quote Yan Friis: "Hard rock is hard, heavy rock is heavy, and heavy metal is English". Black Sabbath's eponymous album is widely considered the first heavy metal album ever created. To this day it remains one of the most influential albums of all time and has served as a template for thousands of bands worldwide. The apocalyptic title track is still often cited as one of the best heavy metal songs of all time. Before Ozzy found dope and reality TV found Ozzy, there was 1970's revolutionary *Black Sabbath*.

A 7-track work of dark, scary fiction, *Black Sabbath* was recorded and mixed in two days. The album is based on the ominous tritone interval (a creepy, menacing musical effect classed as dissonance). Guitarist Tony Iommi also tuned down his guitar (a necessity after the tops of his fingers were cut off in a factory accident) adding to the album's sinister sound. Ozzy Osbourne, yet to find his iconic voice, sings lower and darker on this album than he ever would again. All this combined with heavy blues influences and supernatural themes made Black Sabbath one haunting, historically significant debut.

And then some:
• The title of the track *N.I.B* is said to be a reference to drummer Bill Ward's pointed goatee (shaped like a pen nib).
• *The Wizard* was inspired by the character of Gandalf from J.R.R Tolkien's *The Lord of the Rings*.
• *Behind the Wall of Sleep* is a reference to American writer H.P Lovecraft's 1919 short story *Beyond the Wall of Sleep*.

BLACK SABBATH

**BLACK SABBATH
THE WIZARD
BEHIND THE WALL OF SLEEP
N.I.B.
EVIL WOMAN
SLEEPING VILLAGE
WARNING**

Also by Black Sabbath:
To have but one Black Sabbath entry in this book would be a horrendous transgression, so read on for details of other landmark albums in this band's remarkable career. To whet your appetite, have a listen to *Master of Reality* (1971).

BLACK SABBATH
PARANOID
1970

"We didn't have enough songs for the album, and Tony just played the Paranoid guitar lick and that was it. It took twenty, twenty-five minutes from top to bottom." –And as Bill Ward recalls it, history was made. This rushed piece of filler material became the title track of the album and contains one of the most recognised riffs in metal history. War Pigs was supposed to be the title from the beginning (hence the cover art) but was changed so as not to upset Vietnam War supporters at the time. The album as a whole is steeped in anti-establishment sentiments, with a distinct lack of any satanic connotations. Despite this socio-political (as opposed to oc-cultist) bent, Black Sabbath's reputation for that particular brand of darkness increased with this album.

Paranoid takes another step away from Sabbath's bluesy roots to a stronger sound they would soon become renowned for: heavy, loud and unmistakably metal. Tony Iommi's Gibson growls like a beast from beyond on the more gritty tracks like Electric Funeral but as good as he is at getting low, Iommi's solos are dynamic and epic (his two-minute trip-fest in Planet Caravan is evidence of a man who can cover all bases). Ozzy stepped it up on this album both in terms of effort and pitch to pull off a memorable performance, especially on the slower tracks. Bill Ward truly shines in Rat Salad, which is essentially a lengthy drum solo disguised as a song. Geezer and Ward both drive the album forward and keep it from lingering on the precipice of self-indulgence. Iron Man, War Pigs, Electric Funeral and Fairies Wear Boots are all killer, clas-sic tracks. Heavy metal is Paranoid.

And then some:
• Hand of Doom was written as a warning against heroin abuse.
• Paranoid is Black Sabbath's highest selling album, reaching quadruple platinum in the US.
• Fairies Wear Boots is written about a group of skinheads who harassed the band after a live per-formance.

BLACK SABBATH
PARANOID

1. WAR PIGS
2. PARANOID
3. PLANET CARAVAN
4. IRON MAN
5. ELECTRIC FUNERAL
6. HAND OF DOOM
7. RAT SALAD
8. FAIRIES WEAR BOOTS

Also by Black Sabbath:
Black Sabbath Vol. 4 (1972) and *Sabotage* (1975) will both get your head nodding, if not banging.

BLACK SABBATH
HEAVEN AND HELL
1980

Goodbye Ozzy, hello Ronnie James Dio. Like a benevolent, metal-magic weaving imp, Dio injected new life into Black Sabbath at a time when fans thought all was lost. Ozzy's unwieldy exit signified the untimely end of a tremendous era for the band. Out with the old, in with the slightly older and significantly more compact. Dio (the Italian word for God) bought with him an unbridled love for music and performing and the talent to back it up. Oh, and them horns.

While *Paranoid* was a groundbreaking album for the band and the heavy metal scene at large, *Heaven and Hell* took that power and trebled it. Though Bill Ward was tumbling into the depths of alcoholism, Geezer Butler went AWAL battling through a divorce and Dio had just joined the team, Tony Iommi kept focus and within a year, a metal milestone was created. The musicianship on this album is exceptional. Iommi's monstrous riffs and solos (*Die Young* and *Neon Knights* are shining examples), an inspired rhythm section and competent drumming are kept crisp with some tight production by Martin Birch who went on to produce majority of Iron Maiden's discography. Dio penned all the lyrics on this album in his signature logic-is-for-chumps fashion – "*Love isn't money, it isn't something you buy*"¬– and cemented his reputation as a talented lyricist. Though this line-up wouldn't last, *Heaven and Hell* is timeless.

And then some:
- The cover art for *Heaven and Hell* is a painting called *Smoking Angels* by Lyn Curlee.
- Geoff Nichols plays keyboards on the album but was originally recruited as a possible replacement for Geezer Butler who wasn't around for much of the making of *Heaven and Hell*. He remained Black Sabbath's keyboardist for twenty years after this album, playing offstage during live shows.
- Bill Ward claims to have "no memory" of making the album due to his chronic alcoholism.

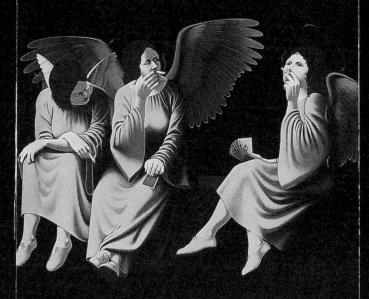

BLACK SABBATH

HEAVEN AND HELL

Also by Black Sabbath:
Aside from the other albums mentioned in this book, *Sabbath Bloody Sabbath* (1973) definitely rates a mention.

BRUCE DICKINSON
THE CHEMICAL WEDDING
1998

What do you do if you're the lead singer of one of the greatest metal bands in the world? Do you a) embark on a tumultuous acting career b) loose yourself in the relentless temptations of drugs and/or groupies c) take your guitar-hero friends and your in-depth knowledge of the dark arts and create one of the most powerful metal albums in the world? If you're Bruce Dickinson (A.K.A Conan the Librarian) you take the latter route, simply because you can.

During his six-year hiatus from Iron Maiden, Bruce Bruce (as he used to be known) produced a sizeable collection of exceptional material under his own good name. *The Chemical Wedding*, though slower than its predecessor *Accident of Birth*, is 57 minutes of atmospheric brilliance. Inspired by William Blake and steeped in dark, alchemical overtones, Dickenson along with guitarists Adrian Smith and Roy Z made metal magic. Driving power chords, an expert rhythm section, intelligent production and epic vocals pull this enormous concept together into one majestic masterpiece. Down tuned guitars add depth to the darkness and well-placed keyboards add the chemical element to the successful marriage of vision and talent.

And then some:
- Dickinson wrote a screenplay entitled *My Chemical Wedding* featuring the title track from the album. The film (about the reincarnation of Aleister Crowley) was released in May 2008.
- As well as being an accomplished singer, writer, radio host and fencer, Dickinson is also a pilot.
- The title track of the album *Tattooed Millionaire* was written about Mötley Crüe bassist Nikki Sixx who slept with Dickinson's (now ex-) wife.

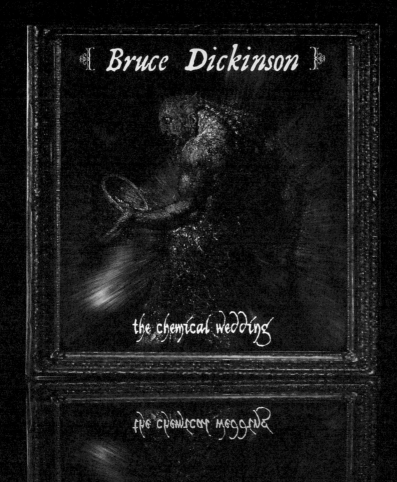

Bruce Dickinson

the chemical wedding

The Dickinson discography begins with *Tattooed Millionaire* (1990) –Bruce's first solo effort while still fronting Iron Maiden (*Fear of the Dark* was released in 1992). This album is Dickinson's breaking-free-from-the-shackles-of-a-big-commercial-band debut and while immature on many fronts, is an important part of the journey. *Accident of Birth* (1997) shows a more focused artist and tells of great things to come in *The Chemical Wedding*.

CANDLEMASS
NIGHTFALL
1987

If one were to imagine a soundtrack to the end of the world (if that ending came in the form of black-winged angels dragging sinners to the pits of hell while the righteous step over the battered bodies of the meek only to peer through the bolted gates of the Promised Land), Candlemass' *Nightfall* would be it. Though the band's debut album *Epicus Doomicus Metallicus* (one of the best album titles ever) was an excellent exploration into the concept of doom metal, *Nightfall* did for the genre what Lemmy Kilmister did for facial hair.

Mesiah Marcolin's grandiose vocals are the very essence of doom. His operatic talents make confident declarations of Leif Edling's ambitious lyrics. The album's themes of death and mourning would be depressing to the point of annihilation if it wasn't for the excellent musicianship and creative songwriting that take the mood from melancholic to majestic. A few up-tempo tracks such as *The Well of Souls* and *At the Gallows End* add pace to the journey whilst staying right on point both musically and thematically. *Nightfall* is an epic story and a supreme example of pure doom metal. This album has influenced countless bands in the genre (Nile's *In Their Darkened Shrines* features a riff of uncanny similarity to the main riff in Candlemass' *The Well of Souls*) and will continue to do so for many years to come. It's big, it's dark, it's essential.

And then some:

• The cover art for *Nightfall* is a work entitled *Old Age* from Thomas Cole's series: *The Voyage of Life*.

• All tracks on the album are written by bassist Leif Edling, with the exceptions of *Black Candles* (written by Mike Wead) and of course *Marche Funebre* –a cover of Frederic Chopin's Funeral March.

• Candlemass won a Swedish Grammy for their 2005 self-titled album.

Also By Candlemass:
Ancient Dreams (1988) is another brilliant offering from these talented Swedes, but really, the first four albums in their catalogue are fairly crucial additions to any metal collection.

CANNIBAL CORPSE
TOMB OF THE MUTILATED
1992

Controversy surrounds Cannibal Corpse like a warm hand-woven blanket. It comforts them and assures their devoted fans that all is right with the world. It would be a sad day indeed when lyrics such as *"As I came, viciously I cut, through her jugular vein/She's already dead, I masturbate with her severed head"* didn't raise an eyebrow or indeed, a law. *Tomb of the Mutilated* as with most Cannibal Corpse material has at one stage or another, been banned in numerous countries. Whilst the general public seems to bulk at the band's recurring themes of butchering and raping (dead) women and children, Cannibal Corpse's supporters lap it up like the sacred discharge of Chris Barnes' ever-weeping wounds.

The music itself is undeniably brutal, technically proficient and in many ways raised the bar in the death metal genre. It is the last of Cannibal Corpse's albums to feature guitarist Bob Rusay who goes out in style, churning out some killer riffs alongside Jack Owen. Paul Mazurkiewicz is creative and vicious with his drums, pushing the album through multiple tempo changes and making clever use of that death metal essential, the blastbeat. Chris Barnes' vocals are sickeningly inhuman. Whilst indecipherable for the most part, it's clear he's spinning some hideous tale of mutilation and carnage in every single track. A new brand of brutality was born with *Tomb of the Mutilated* and it sparked a bizarre series of unforeseeable events: death metal went to Hollywood, censorship became an issue once again, and Satan found a new puppet in Chris Barnes.

And then some:
• Jim Carey cites Cannibal Corpse as his favourite band and gave them a cameo roll in his 1994 film *Ace Ventura, Pet Detective*. Chris Barnes had left the band at that stage and was replaced by George "Corpsegrinder" Fisher.
• The liner notes for *Tomb of the Mutilated* feature quotations from serial killer Albert Fish, a child molester and cannibal who claimed he "had children in every state".
• *Hammer Smashed Face* (along with other Cannibal Corpse songs and lyrics) is frequently referenced on Adult Swim's *Metalocalypse*. One episode features the death of a character from a hammer to the face, using the exact hammer featured on the *Hammer Smashed Face* EP cover art.

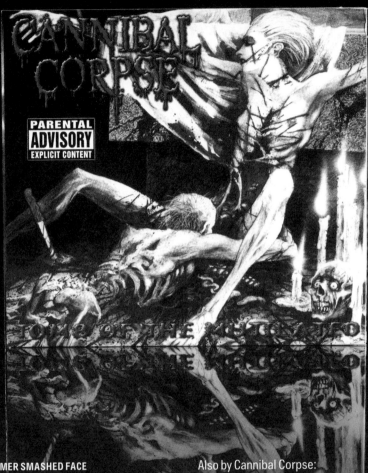

PARENTAL ADVISORY EXPLICIT CONTENT

1. HAMMER SMASHED FACE
2. I CUM BLOOD
3. ADDICTED TO VAGINAL SKIN
4. SPLIT WIDE OPEN
5. NECROPEDOPHILE
6. THE CRYPTIC STENCH
7. ENTRAILS RIPPED FROM A VIRGIN'S CUNT
8. POST MORTAL EJACULATION
9. BEYOND THE CEMETERY

Also by Cannibal Corpse:
1996's *Kill* features the vocal stylings of George "Corpsegrinder" Fisher and is one of the band's best sellers.

CARCASS
hEARTWORK
1993

In 1993, the giant liver-spotted hand of the great grandmother of metal took Carcass by the ear and gave them a good talking too. "Who said metal had to be repulsive?" she nagged. Carcass pulled up their socks and a new era was born. The fantastically gruesome cover art of old was exchanged for creative, aesthetically pleasing material: an H. G. Giger sculpture no less. The nauseating autopsy-themed song titles such as *Crepitating Bowel Explosion* and *Cadaveric Incubator of Endoparasites* morphed into the more palatable *No Love Lost* and *Buried Dreams*. More melody was added, song structures became more metallic and Carcass forayed into melodic death metal.

Bill Steer and Michael Amott are truly brilliant on this album. Their incredible riffs, complex leads and dual guitar battling means the album never gets boring. Amott's melodies show definite leanings toward the kind of material he would go on to explore with Arch Enemy. Jeff Walker's vocals and bass are clearer and more dynamic than on any previous Carcass album. Ken Owen's drums are as fierce as ever with his quick-footed tempo changes, intricate blastbeats and flawless double bass. Though Carcass certainly risked losing fans when they steered away from grindcore, they came up with an intelligent way of keeping the true death metal lovers happy: play good music.

And then some:
- Carcass re-recorded a track for Björk's 1996 *Hyperballad* single.
- Jeff Walker and Bill Steer had a guest appearance on *Red Dwarf* as members of Lister's fictional band "Smeg and the Heads".
- Jeff Walker designed the cover art for Napalm Death's first album *Scum* (1987).

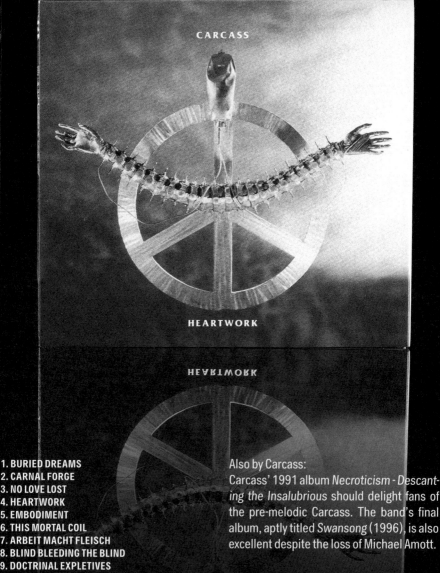

CARCASS

HEARTWORK

1. BURIED DREAMS
2. CARNAL FORGE
3. NO LOVE LOST
4. HEARTWORK
5. EMBODIMENT
6. THIS MORTAL COIL
7. ARBEIT MACHT FLEISCH
8. BLIND BLEEDING THE BLIND
9. DOCTRINAL EXPLETIVES
10. DEATH CERTIFICATE
11. THIS IS YOUR LIFE (BONUS TRACK)

Also by Carcass:
Carcass' 1991 album *Necroticism - Descanting the Insalubrious* should delight fans of the pre-melodic Carcass. The band's final album, aptly titled *Swansong* (1996), is also excellent despite the loss of Michael Amott.

CRADLE OF FILTH
DAMNATION AND A DAY:
FROM GENESIS TO NEMESIS
2003

No one does drama like Cradle of Filth. A 40 piece Budapestian orchestra, a 32 piece film choir, an interpretation of the Old Testament split into four chapters concerning various aspects of the devil: the concept for this album was colossal. With a shiny new contract from Sony tucked in their collective back pocket, COF were inspired to think big. *Damnation and a Day* is almost a cinematic experience. Grand, dark and damning, if you're not checking the locks on your doors or racking your brain for any kind of devil-deterring prayer after the first spin, your system isn't loud enough.

Though there is an emphasis on melody and drama throughout the album, this is by far COF's heaviest offering to date. It is 77 glorious minutes of pure Black Metal. Dani Filth's vocals seem to rise from the depths of hell and the war between good and evil is never more palpable than when Sarah Jezebel Deva's operatic vocals are thrown into the mix. In swapping vampires for Satan, COF seem to have regained some of the raw aggression present on their earlier albums (*The Smoke of her Burning* is a prime example). Adrian Erlandsson's ferocious drumming will have even the most old-school COF fan asking Nicholas who? What line-up change? Many have written COF off in the past as more pleather and lipstick than actual talent. *Damnation and a Day* is a giant, black-nailed middle finger to such sentiments.

And then some:
• David McEwen does the narration on the first track of each section. McEwen played Kemper in *Cradle of Fear* –a low budget horror film starring Dani Filth and featuring cameo appearances by other band members from the Midian era line-up.

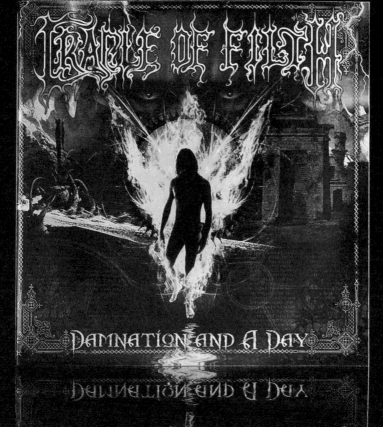

CRADLE OF FILTH

DAMNATION AND A DAY

Also by Cradle of Filth:
Thornography (2006) and *Godspeed on the Devil's Thunder* (2008) are both excellent
examples of Cradle of Filth's far reaching capabilities.

DANZIG

DANZIG

1988

If Jim Morrison and Elvis were able to spawn, Glenn Danzig would be their lovechild. The side-burns, the silky smooth voice, the inner darkness and undeniable charisma... he's the ultimate frontman. Like a metallic Johnny Cash, Glenn Danzig and his band walk the line (incredible pun, you know it) between hard rock and metal. Though the lyrics are dark and the music heavy, there are no blastbeats, no double bass, no pig squeals, satanic growls or flashy production. The songs on Danzig are as simple as they come. Heavy catchy riffs, quality bass and drums, clean vocals. Rick Ruben who produced Slayer's *Reign in Blood* two years earlier showed re-markable restraint on this album, conveying Danzig's signature stripped-back sound in which every old-school riff and sorrowful lyric is audible and profound.

Blues metal by definition is not an overly technical or multilayered genre. Its appeal is in its straightforward delivery of good, uncomplicated music. *Twist of Cain* is the perfect example –an extraordinarily likeable track despite or perhaps because it is based on the phrase *yeah twist of cain /yeah drives my brain*. Elements of doom creep into the album as well on tracks such as *I am Demon* and *The Hunter*, which become almost hypnotic in their simplicity. Glenn Danzig's Mississippi Delta twang, the band's solid support, and laid-back song structures make for 41 minutes of heavy bluesy goodness.

TWIST OF CAIN
NOT OF THIS WORLD
SHE RIDES
SOUL ON FIRE
AM I DEMON
MOTHER
POSSESSION
END OF TIME
THE HUNTER
EVIL THING

And then some:

• Producer Rick Rubin played a large roll in establishing what would become Danzig's signature sound. After signing Samhain to his label Def Jam (later American Record-ings), Rubin suggested their sound should be stripped back, allowing Glenn Danzig's unique voice to become the focal point.

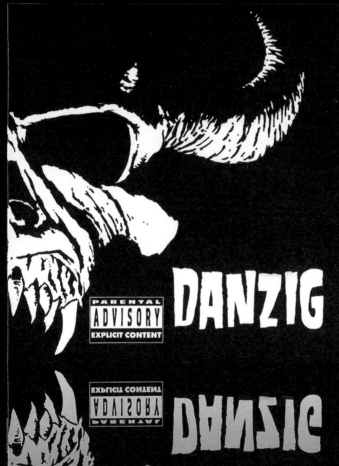

DANZIG

PARENTAL ADVISORY EXPLICIT CONTENT

1. TWIST OF CAIN
2. NOT OF THIS WORLD
3. SHE RIDES
4. SOUL ON FIRE
5. AM I DEMON
6. MOTHER
7. POSSESSION
8. END OF TIME
9. THE HUNTER (BOOKER T. JONES COVER)
10. EVIL THING

Also by Danzig:
Danzig's first four albums are essential.
Get them now, thank me later.

DARK TRANQUILLITY
THE GALLERY
1995

A melodic death metal fan will never know true love or inspiration until they hear Dark Tranquillity's *The Gallery*. This 11-track magnum opus is the epitome of the Gothenburg sound and everything it stands for: namely, excellence. Disciples of Dark Tranquillity have been known to refer to *The Gallery* (quite rightly) as The Bible –a passionate, infallible manual concerning not only the melo-death subgenre or the Gothenburg sound but heavy metal in general. Melodramatic? Possibly. Accurate? Absolutely.

The opening riff of *Punish My Heaven* is often what compels people to buy this album. If you aren't familiar with any of DT's prior work and give this track a spin in a record store listening booth, you'll be sold, no doubt. It's not DT's best ever riff, it's not even the best on the album... it's simply a pleasing indication of things to come. What follows is 47 minutes of exceptional songwriting, achingly dark lyrics and extraordinary musicianship. Mikael Stanne holds his own on vocals proving the best thing Anders Friden ever did was to leave DT and join In Flames. The guitars are clean yet violent and the drumming adds a few more inches to Anders Jivarp's already towering pedestal. This album is intense to say the least. Each track grabs you by the throat and does its bit to ensure that you too will kneel at the altar of Dark Tranquillity.

And then some:
- *The Gallery* was re-released in 2005 as a Deluxe Edition with five cover songs following *...Of Melancholy Burning*. The bands covered include Kreator, Sacred Reich, Iron Maiden, Mercyful Fate and Metallica.
- Dark Tranquillity were formed in 1989 as a thrash metal band called Septic Broiler.
- DT's early demo tapes were remastered and released as part of the 2004 compilation album *Exposures –In Retrospect and Denial*.

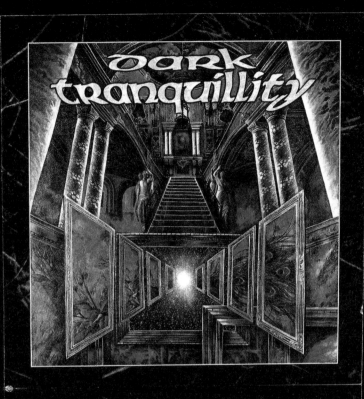

Also by Dark Tranquillity:
The Mind's I (1997), *Damage Done* (2002) and *Fiction* (2007) all serve to prove my theory that there is something in the water in Sweden.

DEATH
HUMAN
1991

Death came to life in 1991. This is one of extreme metal's most defining albums and definitely the best of the band's career. *Human* marked a huge shift in the Death's direction, creating a death Vs thrash debate among their more finicky fans. The songs are tighter –short, fast and straight to the brutal point. The guitars are outstandingly technical with heavy riffs and big, intense solos in every track. Chuck Schuldiner and Paul Masvidal give an old-school death metal feel to the whole album with minor key dual leads and palm-muted riffing. This album was deservedly listed on *Guitar World* magazine's 100 Greatest Guitar Albums of All Time. Budding musicians take note: this album is your bible.

Thanks to some gritty yet clear production, Chuck's incredible vocals are fierce but ultimately decipherable. *Vacant Planets* and *Cosmic Sea* are both stand out tracks in terms of vocals. The lyrics are a little deeper and more introspective than the gore-laden themes of early albums. Though Death are often seen as merely a foundation from which Chuck Schuldiner's star can shine, the rest of the band do have a chance to show their worth on *Human*. Sean Reinhart's drums in particular are pretty much perfect on this album. Innovative and precise, Reinhart urges the listener through 8 of the best tracks in death metal. *Human*'s deep, thick sound will live on long after Death.

1. FLATTENING OF EMOTIONS
2. SUICIDE MACHINE
3. TOGETHER AS ONE
4. SECRET FACE
5. LACK OF COMPREHENSION
6. SEE THROUGH DREAMS
7. COSMIC SEA
8. VACANT PLANETS

And then some:
• Chuck Schuldiner designed Death's logos and its various incarnations throughout the band's career.
• After being hailed as one of the forefathers of death metal, Chuck Schuldiner said in an interview with MetalRules.com: "I don't think I should take the credits for this death metal stuff. I'm just a guy from a band, and I think Death is a metal band".

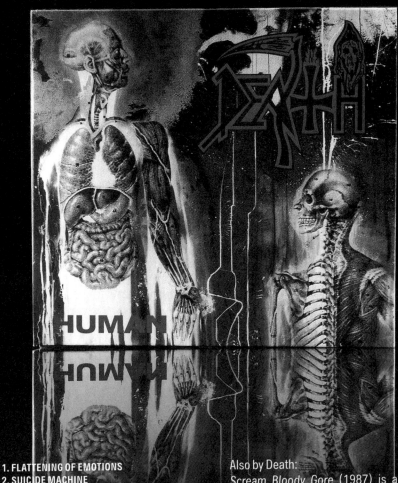

Also by Death:
Scream Bloody Gore (1987) is a definite necessity for any metal fan. Though it may not have the mature sound of *Human*, it's an amazingly good album.

DEEP PURPLE
MACHINE HEAD
1971

One fateful Saturday night in 1971, Frank Zappa and the Mothers lost all their equipment in a raging fire that broke out at the Montreux Casino in Switzerland. Though the group was understandably perturbed, their misfortune would inspire one of the greatest songs in music history. *Smoke on the Water* along with *Never Before*, *Highway Star* and track after classic track of the Machine Head album were recorded in their entirety in a Montreux hotel facility with the Rolling Stones Mobile Studio. Extraordinary circumstances produced an extraordinary album, and a musical benchmark was created.

Machine Head is often cited as the first heavy metal album. Whether you agree with that statement or not, the fact that this album was supremely influential in the development of the heavy metal genre is not up for debate. Anyone who claims to be a metal fan should have *Machine Head* in their collection (perhaps a copy for playing and a copy for framing...just a suggestion). Ian Gillan's vocals are ridiculously good, particularly on *Highway Star* and *Never Before*. Blackmore shreds like a madman throughout the album, battling Gillan for the limelight. John Lord's keys are technically brilliant and haunting at times without any of the pretentiousness of previous Deep Purple albums. Ian Paice's drumming is smooth and effortless as usual. There is absolutely no filler material on this album. Stunning from start to finish.

And then some:
- Though Deep Purple were set to record *Machine Head* at the Montreux Casino, they decided not to unload there equipment until Frank Zappa had left the building ¬–a fortuitous decision as it turned out.
- Deep Purple were once listed in the *Guiness Book of World Records* as the World's Loudest Band.
- When Roger Glover mentioned his idea for a song called *Smoke on the Water*, Ian Gillan dismissed it with the statement "Sounds like a drug song".

1. HIGHWAY STAR
2. MAYBE I'M A LEO
3. PICTURES OF HOME
4. NEVER BEFORE
5. SMOKE ON THE WATER
6. LAZY
7. SPACE TRUCKIN'

Also by Deep Purple:
Fireball 1971, *Deep Purple* (1969) and *Deep Purple in Rock* (1970) would all make decent additions to your collection.

DEFTONES
AROUND THE FUR
1997

Now that's how you start an album: get their attention with some soft vocals and a nice opening guitar line, then smack them upside the head with an exploding chorus riff and some furious screaming. *My Own Summer (Shove it)* is as close as one can get to a perfect song ¬ –hard, heavy and catchy as hell. The only thing lacking is perhaps a warning to those prone to the lead-foot: don't Deftones and drive.

Chino's vocals range from the sweet and angelic to the twisted and tormented on this album. His signature screams are interspersed with almost pretty harmonies (yes, that's metal) and ferocious rapping (still metal). It's moody, dark music that pumps you up and smacks you around. Alongside the heavier tracks, there are a couple of slow, emotional songs like *Mascara* and *Be Quiet and Drive (Far Away)* that have enough energy and brutality to keep both the hard-core and alternative enthusiasts interested. Though The 'Tones built up a pretty loyal fan-base with their 1995 Korn-ish debut *Adrenaline, Around the Fur* put them on the map as one of the most important bands in the alternative metal scene.

And then some:

• *My Own Summer (Shove it)* and *Be Quiet and Drive (Far Away)* were both released as singles with accompanying videos.

• The song *Head Up* was written by Chino and Max Cavalera from Soulfly about the loss of Cavalera's step son and good friend of Chino's, Dana Wells.

• It is rumoured that Stephen Carpenter taught himself to play guitar by playing along with Metallica, Anthrax and Stormtroopers of Death albums after a skateboarding accident left him temporarily confined him to a wheelchair.

deftones
around the fur

1. MY OWN SUMMER (SHOVE IT)
2. LHABIA
3. MASCARA
4. AROUND THE FUR
5. RICKETS
6. BE QUIET AND DRIVE (FAR AWAY)
7. LOTION
8. DAI THE FLU
9. HEADUP (FEAT. MAX CAVALERA)
10. MX
0. BONG HIT ANSWERING MACHINE RECORDING
(HIDDEN TRACK)
0. DAMONE (HIDDEN TRACK)

Also by the Deftones:
White Pony (2001) is a great release and
features some guest vocals by Tool's May-
nard James Keenan, among other musical
highlights. Saturday Night Wrist (2006) is
another excellent, dynamic album.

DEICIDE

DEICIDE

1990

The moment you decide to brand an inverted cross onto your forehead is a special one. It marks the point in your life at which there is no going back. Normality is no longer an option; you have become a slave to controversy and could even consider a name change to Ant. I. Everything. Deicide (meaning the killing of a god) formed their unholy union in 1987 under the name Carnage. From the beginning it was clear that the band's MO was to ride Satan's coattails all the way to metal stardom. Glen Benton's branding antics are but one of a multitude of intentionally offensive behaviours Deicide have explored to keep various tongues wagging.

If one were to listen to Deicide's debut album without any of the hoopla in mind, this is what you would hear: tight, heavy, brutal death metal. Your speakers may melt and the police may be called, but you will have experienced some of the best extreme metal around. Dead By Dawn is an incredibly heavy stand-out track featuring seriously good riffing and passionate screaming. Lunatic of God's Creation (written about Charles Manson) will have you in a neck brace quicker than you can say Sacrificial Suicide. If you like it heavy, Deicide delivers.

And then some:
• Deicide was formed after Brian Hoffman responded to Glen Benton's advertisement in a local music magazine.
• Glen Benton once responded to a request to participate in Bob Larson's Christian radio show by returning the release form stating "fuck you", his signature in blood and the scab he picked off his forehead where he had burned the inverted cross.
• It has been reported that while the band was unsigned and known as Amon, Glen Benton stormed into the office of Monte Connors at Roadrunner Records and presented him with a demo saying "sign us you fucking asshole!" As legend has it, contracts were issued to the band the very next day.

DEICIDE

Also by Deicide
The Stench of Redemption (2006) is 38 minutes of unbridled aggression and a highlight in the catalogue for most Deicide fans. *Till Death Do Us Part* (2008) is another brutal album which, if you were lucky enough to get one of the initial copies, came with a sew-on "Glen Benton for President" patch. Awesome.

DESPISED ICON
THE ILLS OF MODERN MAN
2007

Deathcore may not be one of the more appreciated subgenres of heavy metal, but if Despised Icon have anything to do with it, it's not dying anytime soon. Along with Job For A Cowboy, Beneath the Massacre and All Shall Perish, this six-piece French-Canadian band has definitely staked its claim in the scene. *The Ills of Modern Man* shows a somewhat pared-down band –two vocalists rather than the excessive (if not gimmicky) three of the previous album and tighter song structures. Ex-guitarist Yannick St Armand's production is still fantastically dirty, keeping the vocals as far from clean as possible. Alex Erion and Steve Marios emit ungodly growls and squeals at varying pitches and tempos, keeping the tracks interesting (though lyrically unintelligible).

This album is heavy on the breakdowns, which can only be described as monstrous. Eric Jarren may literally be on fire on this recording if his solos, screeches and super fast triplets are any indication. The drums are delightfully flashy with hyper-speed blasting and awe-inspiring riffs. Swinging maniacally between melodic grooves and pounding assaults, *The Ills of Modern Man* is a fresh, shining example of deathcore. Stand-out tracks include *Quarantine*, *In the Arms of Perdition* and *A Fractured Hand*.

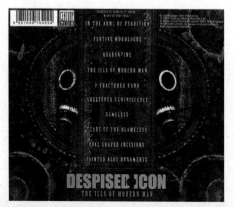

And then some:
- Despised Icon have released three music videos: *The Sunset Will Never Charm Us*, *In the Arms of Perdition* and *Furtive Monologue*.
- The album artwork was designed by Don Clark from Invisible Creature –a graphic design studio run by Don and Ryan Clark who play in the metalcore band Demon Hunter.

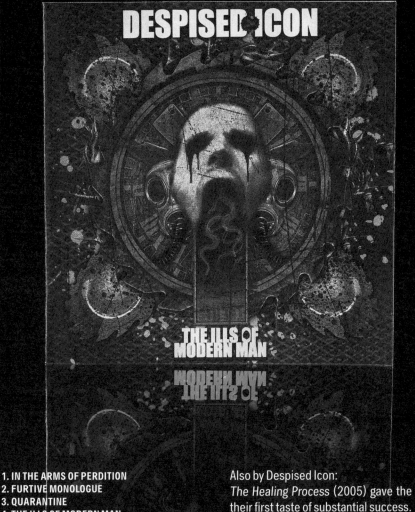

DESPISED ICON

THE ILLS OF MODERN MAN

1. IN THE ARMS OF PERDITION
2. FURTIVE MONOLOGUE
3. QUARANTINE
4. THE ILLS OF MODERN MAN
5. A FRACTURED HAND
6. SHELTERED REMINISCENCE
7. NAMELESS
8. TEARS OF THE BLAMELESS
9. OVAL SHAPED INCISIONS
10. FAINTED BLUE ORNAMENTS

Also by Despised Icon:
The Healing Process (2005) gave the
their first taste of substantial success.

THE DILLINGER ESCAPE PLAN
MISS MACHINE
2004

After a five-year break between albums, fans expected greatness from The Dillinger Escape Plan. And greatness they received, by the truckload. Miss Machine explodes from the get-go with Panasonic Youth ¬–a classic Dillinger freak-out. Van Damsel is another full-out attack, rough and energetic and undeniably fun (in a brutal metal way of course). In between such assaults however, something curious starts to happen. More melodic hooks creep in, tempos slow a little, actual singing can be heard...what in Godsmack's name is this?

Miss Machine's accessibility caused alienated whimpers of "sell out!" amongst Dillinger's exacting fan-base. To the rest of us it seemed the band had matured somewhat during their hiatus. The musicianship is no less accomplished, but it is easier to decipher. The complex time signature changes and interesting sound design are still there, but so are jazz/fusion breakdowns and more comprehensible song structures. The 2001 EP Irony is a Dead Scene with Mike Patton on vocals informs Miss Machine to a large extent. Mike Patton's influence is clearly heard on Setting Fire to Sleeping Giants and Unretrofied. New singer Greg Puciato even sounds like Mike Patton at times; his ability to sing and scream with equal amounts of ferocity is commendable to say the least. All in all, this is an innovative, clever album that should be in the possession of anyone who likes good metal.

And then some:
• Three music videos have been made for Miss Machine: Panasonic Youth, Unretrofied and Setting Fire to Sleeping Giants.
• Greg Puciato was voted one of the 37 greatest metal frontmen in the November 2007 issue of Revolver magazine.
• Bassist Liam Wilson is a devout vegan and has appeared in pro-vegan ad campaigns for PETA.

The Dillinger Escape Plan — Miss Machine

1. PANASONIC YOUTH
2. SUNSHINE THE WEREWOLF
3. HIGHWAY ROBBERY
4. VAN DAMSEL
5. PHONE HOME
6. WE ARE THE STORM
7. CRUTCH FIELD TONGS
8. SETTING FIRE TO SLEEPING GIANTS
9. BABY'S FIRST COFFIN
10. UNRETROFIED
11. THE PERFECT DESIGN

Also by The Dillinger Escape Plan:
Calculating Infinity (1999) is the other full length album in Dillinger's escape plan. That, along with the above mentioned EP, are definitely worth a spin.

DIMMU BORGIR
DEATH CULT ARMAGEDDON
2003

This is the stuff of nightmares. The minute *Death Cult Armageddon* dropped, masters of atmosphere Dimmu Borgir became the undisputed kings of creepiness. But they didn't do it alone. The Prague Philharmonic grew horns and joined in the reign of terror, providing sweeping symphonic depth to the darkness. The vast wall of sound produced by this ungodly joining of forces is penetrable only by the most Satanic of sounds: Shagrath and Vortex's bloodcurdling vocals. The musicianship is stunning with A-grade riffing and Nick Barker (Cradle of Filth, Old Man's Child) working untold magic on the skins. Production is clean, careful and flawless thanks once again to Fredrik Nordström at Sweden's Studio Fredman.

The scope of this album is huge. Each track is powerful and profound in its own way, entirely different from the next. The crowd-pleasing track *Cataclysm of Children* is definitely a highlight, featuring one of the awesome if rare guitar solos on the album. The atmosphere created in *Progenies of the Great Apocalypse* is almost indescribable; it's like Batman has entered the seventh circle of hell...a truly grand, cinematic experience. Dimmu Borgir have cemented their reputation as pillars of the Scandinavian black metal scene. As such, *Death Cult Armageddon* is a right of passage for any fan of the genre.

And then some:

• Shagrath (born Stian Tomt Thoresen) has his stage-name tattooed across his stomach.

• With the release of *In Sorte Diaboli*, Dimmu Borgir became the first black metal band to have a number one album in their native country.

• Before becoming a musician, Silenoz worked in a kindergarten.

Also by Dimmu Borgir:
Stormblåst (1996) is a great album, the last to be written completely in Norwegian. Also, the band's 2007 concept album *In Sorte Diaboli* is a journey worth taking.

DIO
HOLY DIVER
1983

Holy Diver has it all. Packed to the hilt with bona fide classics, there ain't a filler among them. Because this, THIS is the quintessential heavy metal album. What makes it so? Let's break it down. One of the greatest metal frontmen who ever lived: check. Amazingly tight, flawlessly crafted songs: check. Top-notch musicianship by some of the most talented names in the business: hell yeah. *Holy Diver* is one of those albums that makes you think yes, metal is for me. It is single handedly responsible for recruiting whole armies of lost music lovers to the genre. A quick look at the track listing should explain everything.

Stand up and Shout is the monstrous opening anthem that sets the tone for the rest of this superb album. The title track comes in next, with it's slow synth intro and a truly awesome opening riff. Your body will move, it's unavoidable. The lyrics are brilliant, the songwriting faultless and Vivian Campbell's efforts on guitar are breathtaking. Dio's selection of band members couldn't have been better. Jimmy Bain and Vinnie Appice deliver strong performances on bass and drums and Campbell exhibits his remarkable talent without smothering the almighty Dio. *Caught in the Middle, Don't Talk to Strangers* and *Straight Through the Heart* make up one formidable hat trick in the middle of the album. The keyboards on *Rainbow in the Dark* will give you chills. So you see, this is Dio at his absolute best. *Holy Diver* is a landmark album in heavy metal history and if it wasn't obvious already, you need it.

And then some:
• Among a myriad of musical achievements, Ronnie James Dio has performed with Elf, Rainbow and Black Sabbath, officially making him one of the coolest people alive.
• Dio has a street named after him in New York located between Central Avenue and East Court Street named Dio Way.
• Dio took his stage-name from mafia member Johnny Dio.

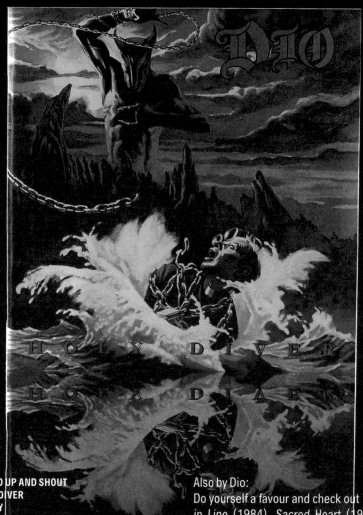

1. STAND UP AND SHOUT
2. HOLY DIVER
3. GYPSY
4. CAUGHT IN THE MIDDLE
5. DON'T TALK TO STRANGERS
6. STRAIGHT THROUGH THE HEART
7. INVISIBLE
8. RAINBOW IN THE DARK
9. SHAME ON THE NIGHT

Also by Dio:
Do yourself a favour and check out *The Last in Line* (1984), *Sacred Heart* (1985) and *Dream Evil* (1987).

DREAM THEATER
IMAGES AND WORDS
1992

"The way your heart sounds/ makes all the difference/ It's what decides if you'll endure/ the pain that we all feel/ The way your heart beats/ makes all the difference/In learning to live". That, my friend, is deep. That is Dream Theater. The band's sophomore release is widely considered a masterpiece, and with good reason. The songwriting on this entire album is nothing short of spellbinding. Epic tracks (ranging from four to twelve minutes), masterful musicianship and profound lyrics make this Dream Theater's best ever release and one of the best progressive metal albums of all time. No question.

Images and Words, as the name would suggest, is riddled with metaphors and similes that paint heart-wrenching pictures of the album's lyrical themes: hope, inner strength, living without fear etc. Each track has its own complete story and its own unique profundity. Operatically trained James LaBrie makes his first appearance on this album as a replacement for Charlie Domenici. Drawing on his glam metal roots, LaBrie's soaring voice takes each track into a realm of sheer majesty. The keyboards are inspired, the drumming is clear and innovative and Portnoy and Myung get multiple opportunities to exhibit their remarkable talents (*Metropolis Pt. 1: The Miracle* is a fantastic showcase for the two of them). Though Dream Theater have been flying the flag for prog-metal since 1985, this album defined them.

And then some:
• Before changing their name from Majesty to Dream Theater for legal reasons, the band considered the names Glasser, Magus and M1. The name Dream Theater (the name of a movie house in Monterey, California) was suggested by Mike Portnoy's father.

• The cover art for Dream Theater's *Live Scenes in New York* was modelled on the Sacred Heart of Christ. Instead of a burning heart, it featured a "Big Apple" with the Twin Towers and entire New York skyline burning in the background. The album was unfortunately released on September 11, 2001 and had to be recalled.

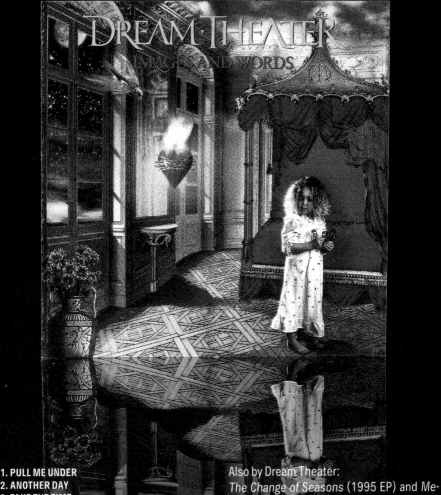

DREAM THEATER
IMAGES AND WORDS

Also by Dream Theater:
The Change of Seasons (1995 EP) and *Metropolis Pt. 2: Scenes From a Memory* (1999) are both important releases for progressive metal.

ENTOMBED
WOLVERINE BLUES
1991

Does accessibility have to equate to the abandonment of ideals? Entombed's 1991 death 'n' roll release polarised fans who labelled the band's development as "selling out". Sure *Left Hand Path* (1990) and *Clandestine* (1991) were both excellent releases, but for those with an open mind, *Wolverine Blues* completes one of the most powerful album hat tricks in Scandinavian metal history. The material is no less aggressive, the musicianship is still amazing. Naysayers take note: metal does not have to give you nosebleeds.

While this album incorporates more mid-tempo grooves, it is not lacking in classic Entombed neck-snappers: *Rotten Soil, Eyemaster* and *Out of Hand* will have you in traction in no time. The drums are thunderous, the guitars are detuned and nasty, the growling is demonic and the production is watertight. In terms of technicality, Entombed have moved away from the stylistic trappings of Byzantine death metal, favouring more concise song structures. *Wolverine's* focus is nevertheless heavy; the positively primal beats and expert fretwork will appeal to even the purists among you and the wah-wah leads are inspired to say the least. Entombed are still brutal metal gods, they're just easier to get along with.

And then some:
• Unbeknownst to Entombed, Marvel Comics made a deal with Earache Records to sponsor the album. As a result, a version of *Wolverine Blues* was released with *X-Men* character Wolverine on the cover and a mini comic lift-out inside.
• In 2001, Entombed worked with the Royal Swedish Ballet among other performance artists on a production entitled *Unreal Estate*.
• Entombed performed with the RSB in-tow at the Swedish Grammies in Stockholm.

Entombed

Wolverine Blues

Also by Entombed:
The previous two albums from the afore-mentioned arse-kicking trilogy should be on your wish list: *Left Hand Path* (1990) and *Clandestine* (1991).

EXODUS
BONDED BY BLOOD
1985

Nothing says metal like a set of conjoined infant twins embodying the duelling fundamental natures of good and evil. The concept is one that has plagued Exodus since their inception in 1980. Good: The band was formed by Gary Holt, Tom Hunting and all-round-hero Kirk Hammett. Evil: Hammett left to join Metallica before ever making a recording. Good: Hammett's influence helped create Exodus' signature sound. Evil: the deaths of two band members, various hiatuses and "issues" with record companies. Good: *Bonded by Blood* is one of the most influential thrash metal albums of all time. Evil: Due to various obstacles, the release was pushed back a year, causing the band to miss the crucial thrash metal upsurge which reached its peak in 1985.

Nevertheless, *Bonded by Blood* still sits atop most thrash metal enthusiasts' collections. The 40-minute onslaught begins with the punishing title track. It contains some of the slickest lyrics in thrash: *"Murder in the front row/ crowd begins to bang/ and there's blood upon the stage/ bang your head against the stage/ and metal takes its price/ bonded by blood"* ...you will be in the finest kind of pain, guaranteed. The "all killer no filler" label definitely applies to this album with anthem after anthem of rampant brutality. *A Lesson in Violence* is a crash-course in thrash fundamentals and the slower *And Then There Were None* will have you kneeling in praise of Exodus' musicianship. Thrash at its finest.

And then some:
• Gary Holt is the only member of Exodus who has played on every album.
• Vocalist Paul Baloff died in 2002 after suffering a stroke.
• In October 2008, Gary Holt released an instructional guitar DVD called *A Lesson in Guitar Violence*.

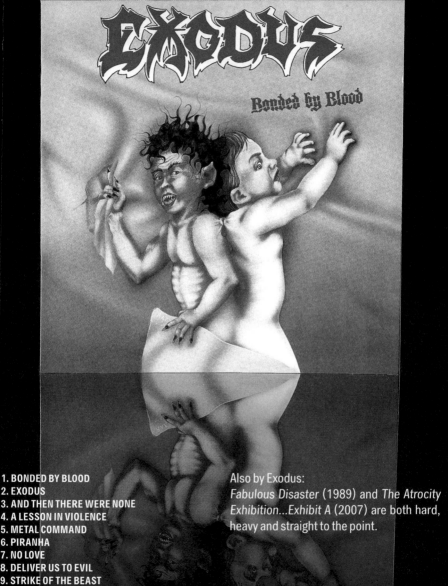

1. BONDED BY BLOOD
2. EXODUS
3. AND THEN THERE WERE NONE
4. A LESSON IN VIOLENCE
5. METAL COMMAND
6. PIRANHA
7. NO LOVE
8. DELIVER US TO EVIL
9. STRIKE OF THE BEAST

Also by Exodus:
Fabulous Disaster (1989) and *The Atrocity Exhibition...Exhibit A* (2007) are both hard, heavy and straight to the point.

GAMMA RAY
LAND OF THE FREE
1995

The beautifully crafted *Land of the Free* is without a doubt, the definitive power metal album. Ex-Helloween vocalist Kai Hansen steps up to the mic in place of Ralf Scheepers and does a truly stupendous job. Whilst it is tragically common for power metal vocalists to lose themselves in the heady higher registers, Hansen puts on a dynamic performance. His aggression and sincerity are palpable in every track, keeping the vocals grounded and saving his piercing falsetto for when the time is right. Guest vocals by Hansi Kürsch (from Blind Guardian) and Michael Kiske (from Helloween) bring freshness to *Farewell* and *Time to Break Free* respectively, but Kai reigns supreme.

Rebellion in Dreamland is one of Gamma Ray's finest moments, blending melody and power in equal mind-blowing proportions. The title track, like the ultimate lover, has it all: heroic guitar leads, a catchy sing-along chorus, pleasing tempo changes...air guitar is an inevitable consequence of such greatness. Gamma Ray mix solid speedy songs (as in the infectious *Man on a Mission*) with haunting ballads such as *Afterlife*. No matter the tempo, Gamma Ray are always on point. *Land of the Free* marks that moment in music history where German power metal grew teeth.

And then some:
• *Afterlife* was written in memory of drummer Ingo Swichtenberg from Helloween who committed suicide in early 1995.
• Before officially joining the band as a guitarist, Dirk Schlächter appeared as a guest bass player on Gamma Ray's first album *Heading for Tomorrow*.
• Kai Hansen has done guest appearances for Angra, Blind Guardian, Hammerfall, Stormwarrior, Heavenly and Headhunter among other bands.

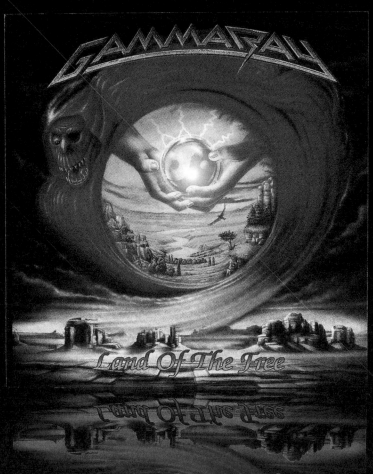

GAMMA RAY

Land Of The Free

Also by Gamma Ray
Majestic (2005) and *Land of the Free II* (2007) are good follow ups to 1995's magnum opus.

GODSMACK
IV
2006

The words "mandolin" and "heavy metal" don't often appear in the same sentence. They're like chalk and cheese or Angela Gussow and Shakira. But then along came Godsmack. The band's fourth studio album is imaginative to say the least. Acoustic guitars, strings, tribal drums, the aforementioned mandolin and even some well-placed harmonica make this a unique release in the heavy metal genre. Heavily influenced by Alice in Chains and Metallica, Godsmack have done their level best to make a record that cleanses them of any copycat accusations. *IV* is hooky and catchy with great big riffs, and a little something extra.

Sully Erna gave his all on this album. Not only does he rock the rhythm guitar, he sings, plays some wicked harmonica and takes on production duties. There are countless "God"-complex puns that could be made here but they don't seem fair since he took it all in his stride with undeniable panache. This album is quality all the way through. Larkin and Merrill keep the bass and drums tight, allowing breathing space and giving Erna's Staley-inspired vocals a chance to take hold. Tony Rambola reins in the power chords on *IV* (as opposed to previous releases) making room for some outstanding solos. Aside from the three singles released from this album (*Speak, Shine Down* and *The Enemy*), *Hollow* and *Bleeding Me* are stunning standout tracks.

And then some:
• *IV* is Godsmack's first studio album to be produced by Andy Johns who also engineered Led Zeppelin's *IV* among other classics.
• The songs *Straight Out of Line* and *I Stand Alone* from the *Faceless* album received Grammy nominations for Best Rock Song and Best Hard Rock Song respectively.
• Robbie Merrill is a left-handed musician but writes with his right hand.

Also by Godsmack:
Faceless (2003) should be in your shopping basket.

GOJIRA
THE WAY OF ALL FLESH
2008

Gojira's 2005 release *From Mars to Sirius* exploded like a nail bomb in the death metal scene. Nervous excitement trailed in its awesome wake...can they do it again? They can and they did, only better. Gojira's *The Way of All Flesh* is a cataclysmic album boasting twelve tracks of raging fury. The lyrics are intelligent, the themes damning and sheer sonic brutality is overwhelming. If you enjoy a good hammer-drill to the scull, this is the album for you.

Gojira throw everything they can at the listener in this diabolical attack. Diverse tempos and textures, schizophrenic vocals, gnawing, grinding guitars: the pace is extreme. Joseph Duplantier's screams and shouts tell tales of catastrophe, urging the listener ever closer to impending Armageddon. Mario Duplantier's drums are crushing in their clarity; every blast of his snare is profound. Labadie's bass gives the whole album a full-bodied sound and the guitars churn relentlessly from the depths of hell. To the bitter end, *The Way of All Flesh* moves like a beast on the hunt –frantic and desperate with dogged determination.

And then some:

• A hidden instrumental lies at the 12.33 minute mark of the final (title) track.

• As well as playing on *The Way of All Flesh*, Joe Duplantier produced the album and designed the cover art.

• A music video for the single *Vacuity* was released in 2008. The video was shot near the band's hometown of Bayonne in France and stars the Duplantier brothers' cousin, Claire Theodoly.

GOJIRA

the way of all flesh

Also by Gojira:
From Mars to Sirius (2005) put Gojira deservedly on the progressive death metal map and demands your attention.

GUNS N' ROSES
APPETITE FOR DESTRUCTION
1987

The mid to late 80s was an interesting time for heavy metal and heavy rock. The femininity of the emerging glam metal scene that erupted out of Los Angeles was at odds with the hyper-masculine image of traditional heavy metal. Then along came Guns N' Roses, the bastard child of hair metal, punk, blues and hard rock who turned everything on its head. Whilst initially borrowing from the glam metal aesthetic, Guns N' Roses' lyrics dealt with the seedy reality of the excesses espoused by bands like Mötley Crüe.

After more than twenty years, *Appetite for Destruction* is still the world's fastest-selling debut album, and it's easy to see why. Songs like *Welcome to the Jungle, Paradise City*, and the number one hit *Sweet Child o' Mine* were destined to become arena and air guitar anthems, appealing to both metal fans and mainstream punters alike. The production on this album still stands up as one of the best in hard rock, though producer Mike Clink never really got the praise he deserved. Every instrument comes through with crystal clarity in the mix, something that many heavy metal bands can't get right some two decades later. There's not a lot that hasn't already been said about this album, except that if you haven't heard *Appetite for Destruction* you need to take a long hard look at yourself.

And then some:

• *Kerrang!* and *Metal Hammer* magazines both ranked *Appetite for Destruction* #1 in their respective greatest metal albums lists.

• The name Guns N' Roses is a hybrid of the band members' former groups L.A. Guns and Hollywood Rose.

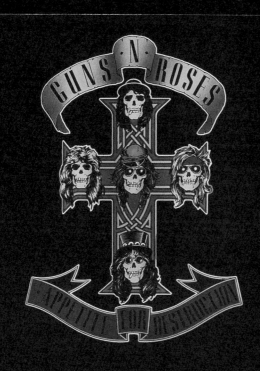

Also by Guns N' Roses:
Do yourself a favour and pick up *Live ?!*@ Like a Suicide* (EP, 1986), *Use Your Illusion I* and *II* (1991), and the underrated punk/glam cover album "*The Spaghetti Incident?*" (1990).

HAMMERFALL
LEGACY OF KINGS
1998

Legacy of Kings is a 10-track war cry. The opener alone should be enough to call all metal warriors to arms: *Heeding the call, one and for all / never surrender, with glory we'll fall / brothers unite, let's stand up and fight / fulfilling our fate, we are heeding the call.* It's vocally catchy and emotionally empowering. If medieval kings had hi-fi systems, this album would've been the ultimate propaganda material. Wagner Schmagner, HammerFall know how to incite action.

After the success of their debut album *Glory to the Brave*, HammerFall had their work cut out for them. Two years later, they emerged triumphant releasing an impressive album replete with knights-of-the-round-table grandeur. Uplifting up-tempo tracks such as *Stronger Than All* and *Warriors of Faith* serve to rally the troops and prove that HammerFall are champions of the old-school. As well as mid-paced rockers, there are grand, rousing power ballads such as *Dreamland* (which contains one of Dronjak's best guitar solos) that give the album depth and showcase Joacim Cans' glorious vocals. It's Helloween meets Manowar and King Arthur.

And then some:
- HammerFall were nominated for a Swedish Grammy in the category of Best Hard Rock Act.
- Joacim Cans competed in a Swedish TV show called *Körslaget* or *Clash of the Choirs*. His choir team won the entire competition.
- Before settling on the guitar, Oscar Dronjak played the accordion and trombone.

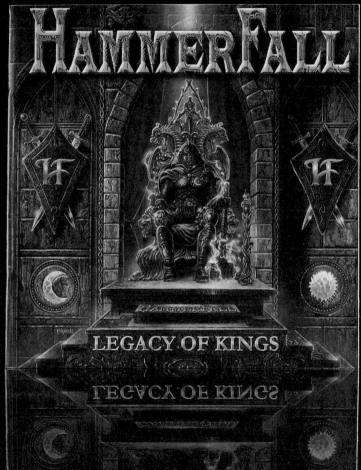

HAMMERFALL

LEGACY OF KINGS

Also by HammerFall:
Glory to the Brave (1996), *Crimson Thunder* (2002) and *Chapter V: Unbent, Unbowed, Unbroken* (2005) will get your fist in the air.

THE HAUNTED
MADE ME DO IT
2000

If At the Gates slaughtered your soul, The Haunted will most definitely make you do it. Get angry. Get rowdy. Get ready to be smacked in the head with a two-by-four of metal genius. Above all, get this album. Whatever subgenre floats your brutal boat, The Haunted have got you covered on this, their second full-length offering. *Made Me Do* It is a little bit Slayer, a little bit ATG, a whole lotta thrash.

The differences between this album and the band's self-titled arse-kicking debut are significant, conspicuous and specifically designed to incite worship. The most obvious changes are in the line-up: Marco Aro replaced Peter Dolving on vocals and Per Möller Jensen took control of the sticks when Adrian Erlandsson left to join Cradle of Filth. Many fans were sceptical about the line-up change and the effect it would have on The Haunted's winning formula. Those fears were shot to hell the minute *Made Me Do* It dropped. This album delivers speedy, aggressive thrash with death metal intensity in an altogether cleaner sound than on their previous album. If you thought The Haunted were merely the less impressive bastard child of At the Gates, tracks like *Bury Your Head, Hollow Ground* and *Trespass* will no doubt change your mind, if not your life.

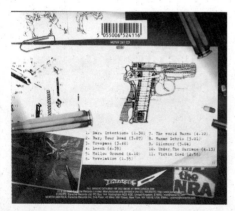

And then some:
- *The Haunted Made Me Do It* won a Swedish Grammy in the category of Best Hard Rock Album.
- *Made Me Do It* was re-released in 2001 with *Live Rounds in Tokyo* as a bonus CD.
- Marco Aro left the band in 2003 at which stage original vocalist Peter Dolving returned as frontman.

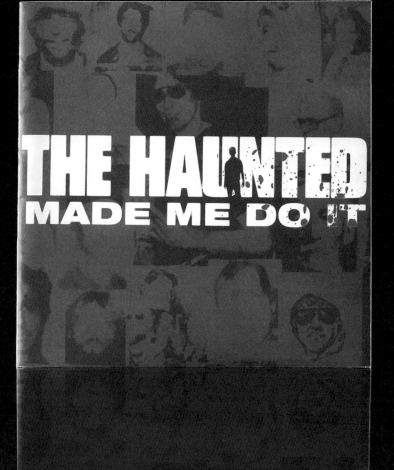

Also by The Haunted:
One Kill Wonder (2003) is a great album.
2004's *rEVOLVEr* is even better and would
have its own entry if this book were called
the 101 Best Heavy Meal Albums.

HELLOWEEN

KEEPER OF THE SEVEN KEYS PT. II
1988

Despite good (if not predominantly fiscal) intentions, most sequels are tragic, imitations of the first production. *Jaws 2*, World War II, countless celebrity marriages –all failed like sad wrinkled balloons. *Keeper of the Seven Keys Pt. II* however, is Helloween's ultimate achievement. This album maintains the winning formula of *Pt. I* but with tighter musicianship, clearer production and superior songwriting. The jewels contained within have been covered by the likes of Gamma Ray, HammerFall, Vision Devine, Bassinvaders, LORD and Sonata Arctica. The decision among the power metal elite is unanimous: this sequel surpasses the original.

Michael Kiske has some of the shiniest pipes in metal. His vast octave range and vocal sincerity have few comparisons in the power metal genre (Bruce Dickinson, Geoff Tate and Timo Kotipelto are immediate, obvious exceptions). Kiske's performance on *Land of the Free Pt. II* is epic and pays homage to Michael Weikathi's imaginative songwriting. This is the last Helloween album to feature Kai Hansen who left to form the almighty Gamma Ray. Hansen's final performance is passionate and flawless as is every other band member's. You wont be bored. You won't be longing for the glory of 1987. You'll become a life-long Helloween fan.

And then some:
• Kai Hansen reportedly wrote the song *I Want Out* to reflect his desire to leave the band.
• Markus Großkopf began playing bass at the age of 15.
• Helloween was formed in Hamburg Germany in 1984 by Kai Hansen (vocals), Michael Weikgath (guitar), Markus Großkopf (bass) and Ingo Schwichtenberg (drums).

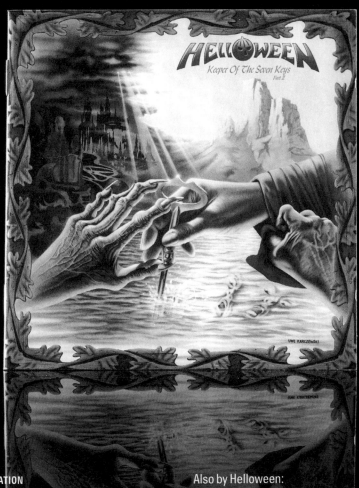

Also by Helloween:
Helloween (EP, 1985), *Walls of Jericho* (1985) and *Keeper of the Seven Keys Pt. I* are all classic Helloween releases. *The Dark Ride* (2000) shows what Helloween can do when they get heavy.

IN FLAMES
WHORACLE
1997

It's hard to say exactly what happened between 1995 and 1997. Were In Flames bullied? Was the Swedish winter particularly brutal? Did Jesper Strömblad open up a can of stinky rotting fish in the In Flames rehearsal room? Whatever it was, the band got cranky. The floodgates of melodic rage were flung open on *Whoracle*, and In Flames unleashed new and improved forms of rhythmic and technical aggression on their grateful listeners. If *The Jester Race* put In Flames on the map, *Whoracle* fortified their reputation as melodic death metal superheroes and pillars of the Gothenburg scene.

As a concept album, *Whoracle* had a lot of ground to cover. The rise and fall of society, the demolition of a utopian world order caused by the intrinsically destructive nature of man, the dismal future and impending termination of planet Earth...In Flames were thematically ambitious in their songwriting, no doubt. Such a notion could only be dragged from the realm of hypotheses into plausibility by this most gifted of bands. With ominous drumming, low riffing, a breathtaking lead guitar and loud, desperate screaming, In Flames have you believing the apocalypse is nigh.

1-Jotun 2-Food for the gods 3-Gyroscope
4-Dialogue with the stars 5-The hive
6-Jester script transfigured 7-Morphing into primal
8-Worlds within the margin 9-Episode 666
10-Everything counts 11-Whoracle

And then some:
• All the lyrics for the album were written in Swedish by Anders Friden and then translated into English by Dark Tranquillity guitarist Niklas Sundin.
• Björn Gelotte plays both drums and lead guitar on the album.
• *Everything Counts* is a Depeche Mode cover from their 1983 album *Construction Time Again*.

IN FLAMES

WHORACLE

Also by In Flames:
In Flames have produced a truly impressive catalogue of releases. All of these are well worth your time: *The Jester Race* (1995), *Colony* (1999), *Clayman* (2000) and *Reroute to Remain* (2002).

IRON MAIDEN
THE NUMBER OF THE BEAST
1982

What is there to say about Iron Maiden that hasn't already been said? *The Number of the Beast* is essential metal—a classic album from a band that is beyond prolific and continues to knock the studs off metalheads around the world. A No. 1 hit on the UK charts and highly successful internationally, *The Number of the Beast* cemented new (and longest-running) frontman Bruce Dickinson's place in the band, and heralded a new era of success for Maiden. The fast-paced vocals and infectious melodies are in a league of their own on this album, which remains one of the band's finest offerings.

Invasion kicks the door down with a sharp chorus and guitar hook, while *The Prisoner* sucker-punches the listener before demanding solidarity in the fight for freedom. And then there's the title track, which contains one of the most memorable opening riffs ever created, not to mention guitar solos designed to make an amateur's fingers bleed. In just nine tracks totalling less than 45 minutes, this album manages to pack in tales of ghosts and persecution, blind faith and deep despair, frantic hope and sheer terror. *The Number of the Beast* is pure metal mythology in action.

And then some:

• The track *The Prisoner* begins with a sample from the namesake BBC television show from 1967.

• Bruce Dickinson is a qualified pilot and was behind the controls of the band's Boeing 757 during their 2008 *Somewhere Back In Time* world tour.

• Bassist Steve Harris has the band's mascot "Eddie" tattooed on his arm.

Also by Iron Maiden:
Reminisce the pre-Dickinson era with 1980's *Iron Maiden* and see how far they've come by sampling *A Matter of Life and Death* (2006).

IRON MAIDEN
PIECE OF MIND
1983

Most metal fans (particularly those growing up in the early eighties) remember exactly where they were and what they were doing the first time they heard Iron Maiden's *Piece of Mind*. Whether you were ten years old and just starting your vinyl collection or sixteen and squeaking out some rough chords on your first guitar, *Piece of Mind* changed you. Bruce Dickinson had settled into his role as one of the greatest frontmen in history, Nicko McBrain (from the French band Trust) had replaced Clive Burr and Iron Maiden would never be the same. Though *The Number of the Beast* brought them well-deserved notoriety, *Piece of Mind* showed Iron Maiden at their most confident with a sharper sound and an album full of great ideas.

The thematic content is pure Maiden: intelligent, creative and stimulating. *The Trooper* –one of the band's biggest ever tracks– is based on Tennyson's *Charge of the Light Brigade*. *Flight of Icarus* features one of the best call-and-response solos in metal and puts an Iron Maiden spin on Greek mythology. *To Tame a Land* is based on Frank Herbert's science fiction novel *Dune* and features themes from the classical guitar showpiece *Leyenda (Asturias)* by Spanish composer Isaac Albéniz. Classy, yes indeed. Such high-brow content is made convincing with dramatic, husky vocals from the almighty Bruce Dickinson. Dave Murray and Adrian Smith make a far more coherent team here than on *The Number of the Beast* and pull-off superbly crafted riffs and solos throughout. Steve Harris busts out strong melodic bass lines and Nicko McBrain cements his place not only in the band, but in the hearts and minds of Iron Maiden fans everywhere. *Piece of Mind's* insatiable metal energy has stood its ground for nearly 30 years. Forget diamonds and war relics, this is your family heirloom. Pass it on.

And then some:
• Nicko McBrain recorded a hidden message at the beginning of *Still Life* that can only be understood when played backwards.
• *Piece of Mind* is the first Iron Maiden album to feature a title not taken from the track listing.

IRON MAIDEN
Piece of Mind

Also by Iron Maiden:
Somewhere in Time (1986) and *Seventh Son of a Seventh Son* (1988) will literally rock your socks all the way off.

IRON MAIDEN
POWERSLAVE
1984

In 1984 it was almost impossible to be in a public place and not see at least eighteen people with fashionably tattered Iron Maiden t-shirts stretched across their chests. The band was at its peak of popularity, standing atop the music mountain surveying the scene they'd created. Many a fine musician may have decided at that point to rest on their laurels. But this was Iron Maiden, they of the purest metal hearts. Powerslave dropped in 1984, which made five albums in five years without one iota of fatigue.

After the raging success of Piece of Mind, Maiden made one of the cleverest moves of their career: they did nothing. The line-up stayed the same, their melodic focus remained unaltered. The album opens with Aces High, possibly one of Iron Maiden's greatest singles. Dickinson's high pitched screams reflect the horror of the Battle of Britain from the perspective of an RAF pilot. It's a powerful, meticulously crafted song and one of the best openers of any Maiden release. The songwriting is just as poignant and just as inspired throughout the entire album. Colossal tracks like 2 Minutes to Midnight and the powerhouse title track are sandwiched between the epic Rime of the Ancient Mariner and Back in the Village (a definite album highlight). It doesn't get much better than this. Powerslave is Iron Maiden and heavy metal at its absolute best.

And then some:
- Rime of the Ancient Mariner is based on Samuel Taylor Coleridge's poem of the same name.
- 2 Minutes to Midnight was written by Adrian Smith and Bruce Dickinson in reference to the Doomsday Clock —a symbolic clock face used by the Bulletin of the Atomic Scientists to represent humankind's proximity to catastrophic destruction.
- Nicko McBrain was born Michael Henry McBrain but was nicknamed Nicko in childhood. The name is said to be taken from the drummer's favourite stuffed toy "Nicholas the Bear".

ACES HIGH
2 MINUTES TO MIDNIGHT
LOSFER WORDS (BIG 'ORRA)
FLASH OF THE BLADE
DUELLISTS
BACK IN THE VILLAGE
POWERSLAVE
RIME OF THE ANCIENT MARINER

Also by Iron Maiden:
Killers (1981) and *Fear of the Dark* (1992)
are both illustrious releases but really, the
whole catalogue is pretty fantastic.

ISIS
PANOPTICON
2004

Metal, in general, is a genre that is best experienced as loud as possible. But if you had to pick one band to demonstrate it's volume-demanding qualities, that band would be Isis. *Panopticon* is an album best enjoyed lying down, speakers face down on the floor staring at the sky while the ebb and flow of the album washes over you.

The seven tracks on display here are epic in every sense of the word, each lengthy soundscape using repetition and measured chord progressions to build complex and emotional songs owing as much to psych-rock as they do prog-metal. Every track charts a mounting sense of tension and apprehension, the gentler passages highlighting the intensity and drama of the crushing crescendos. Isis are a band that know exactly what they are doing every step of the way, and while it's loud, distorted and angry, it's what they hold back that really matters. The sense of restrained aggression (highlighted by frontman Aaron Turner's hypnotic mix of raw, growled vocals and soaring melodies) is what sets them apart from many of their more unhinged contemporaries.

Panopticon is sinister and enlightened, powerful and controlled all at once, and above all supremely intelligent. It's real end-of-the-world type stuff, and there's little doubt *Panopticon* will be on global broadcast when the locusts do set in.

And then some:
- The album manages to name drop Foucalt and Jeremy Bentham, and that's just in the title! Heavy.
- In the words of guitarist Aaron Turner, "Isis formed as a result of the dissatisfaction with past bands of the founding members. None of us were happy with what we were doing musically at the time, two of us lived together, we had similar tastes and similar record collections".

ISIS
PANOPTICON

Also by Isis:
Isis haven't released a bad record, but 2002's *Oceanic* was the first to truly achieve the sound they are acclaimed for.

JUDAS PRIEST
BRITISH STEEL
1980

If you were raised on black metal, if church burnings seem appropriate, if Per "Dead" Ohlin's suicide was a defining moment in your life...you probably won't own this album. Every other metalhead worth their salt will. *British Steel* was everyone's first Priest album and no doubt holds pride of place on metal mantels from Sweden to Australia. And why wouldn't it? British Steel is the album that made Judas Priest globally and irreversibly successful and provided a musical boot to the face of anyone stupid enough to suggest that selling well meant selling out.

British Steel is one of the best party albums ever made. It's ridiculously catchy, heroically energetic and (the essential ingredient for those on the sauce) easy to follow. It is rampant rebellion with a paint-by-numbers feel, only Judas Priest weren't following a formula, back in 1980, they were the formula. The song structures are simple verse/chorus/verse arrangements; the sound is stripped down and straightforward. Guitar gods Glenn Tipton and KK Downing dish out razor sharp riffs, Ian Hill is subtle and supportive as ever (except in *Rage*) and Dave Holland keeps that steel ball rolling with steady, precise drumming. Don't be fooled by *British Steel*'s accessibility, this is pure heavy metal. *Breaking the Law, Rapid Fire, Metal Gods, You don't Have to be Old to be Wise, Steeler*...enough said.

And then some:
- *British Steel* was recorded in Tittenhust Park, the former home of Ringo Starr.
- As sampling wasn't available in 1980, the sounds of milk bottles being smashed and trays of cutlery being shaken were recorded for the album.
- *British Steel* was reissued in 2001 with *Red White and Blue* included as a bonus track.

Also by Judas Priest:
Sad Wings of Destiny (1976) and *Screaming for Vengeance* (1982) prove Judas Priest deserve every ounce respect afforded them by true fans of metal.

JUDAS PRIEST
PAINKILLER
1990

Judas Priest have experienced a number of milestones in their long, dazzling career. Their debut album *Rocka Rolla* put them on the metal map in 1974. 1980's *British Steel* brought them well-deserved commercial accolade. The release of *Turbo* in 1986 saw the steamroller of success come to a screeching halt as fans bemoaned the loss of another great band to mediocrity. Judas Priest had some thinking to do. What did fans want? What did they need? In 1990, the band came out with all guns blazing and the heaviest ever Judas Priest album was unleashed on a dumbstruck public.

Painkiller is one of the best speed metal albums ever released. The mid-paced ear candy of the *British Steel* era was replaced with ludicrously fast shredding, incredible solos, fearless vocals and the most vicious drumming to ever grace a Judas Priest album. With Rob Holland out and Racer X's Scott Travis most definitely in, the Priest had a new, gloriously ruthless sound. *Painkiller*'s unprecedented brutality tempered with melody and undeniable catchiness inspired countless bands across the globe such as Gamma Ray and Primal Fear. Tracks like *Metal Meltdown* (blastbeat mania) and the spooky *A Touch of Evil* make it hard to believe this is the same band that produced *Rocka Rolla* all those years ago. But then you hear Halford's signature screams and Glenn Tipton's virtuoso leads and you nod in quiet admiration: the Priest had it all along.

And then some:
- *Painkiller* received a Grammy in the category of Best Metal Performance at the 33rd Annual Grammy awards in 1991.
- Rob Halford left the band after recording *Painkiller* to start the band Fight but reunited with Judas Priest in 1993.
- *Painkiller* is produced by Chris Tsangarides who also produced *Sad Wings of Destiny* in 1976.

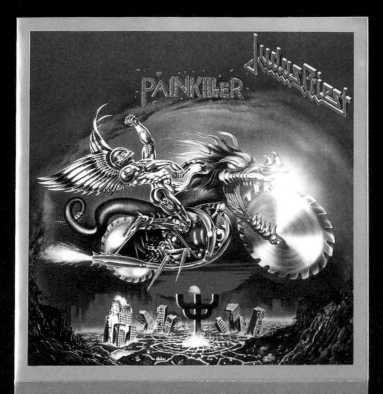

1. PAINKILLER
2. HELL PATROL
3. ALL GUNS BLAZING
4. LEATHER REBEL
5. METAL MELTDOWN
6. NIGHT CRAWLER
7. BETWEEN THE HAMMER & THE ANVIL
8. A TOUCH OF EVIL
9. BATTLE HYMN
10. ONE SHOT AT GLORY

Also by Judas Priest:
Defenders of the Faith (1984) is another of
Judas Priest's finer offerings.

KILLSWITCH ENGAGE
THE END OF HEARTACHE
2004

If all you've heard of Killswitch Engage is their contribution to the Freddy Vs Jason soundtrack, where the Helloween have you been? Since their debut in 2000 and the excellent *Alive or Just Breathing* dropped in 2002, Killswitch Engage have been diligently etching their good name into the minds of metalheads everywhere. *The End of Heartache* tore the scene apart in 2004 with its something-for-everyone approach to metalcore. Bone-crushingly heavy, yet beautifully melodic, this album mixes the best of the old-school into nu-metal with Swedish influences and a whole lotta heart(ache).

Howard Jones (thankfully, not that Howard Jones) stepped into the gaping hole where Jesse Leach used to be and puttied up the cracks with his spectacularly soulful vocals. Justin Foley did the same, making sure no one would pine for Tom Gomes. MVP Adam Dutkiewicz gives outstanding performances on guitar, backing vocals, additional percussion and engineering with a Malmsteen style finger-in-every-pie determination. Stroetzel's axe grinding is inspired and impressive and D'Antonio pulls the whole shebang together with his tight, groove-laden bass lines. Whatever opinions you may have of the American nu-metal scene, *The End of Heartache* contains twelve of the best tracks to ever cross the Atlantic.

And then some:

• Justin Foley and Howard Jones were both members of mathcore band Blood Has Been Shed before joining Killswitch Engage.

• Two music videos were made for the album: *Rose of Sharyn* and *The End Of Heartache*.

• A special edition of the album was released in 2005 containing six additional tracks.

KILLSWITCH ENGAGE

Also by Killswitch Engage:
Alive or Just Breathing (2002) is a passionate, energetic album from the original line-up.

KING DIAMOND

ABIGAIL

1987

You want metal? How about a woman giving birth in a haunted house to an illegitimate child who is actually the reincarnation of a stillborn baby girl named Abigail born sixty-eight years earlier? Throw in the death of her parents, seven horsemen and Count LeFey (the family ghost) and you've pretty much got it: one creepy concept album. Leave it to King Diamond to conceive an album almost as ostentatious as he is. Almost.

The cavalcade of talent is what raises this album out of the doldrums of self-indulgence. Andy LaRocque plays his heart out, soaring effortlessly through unbelievable solos, reaching new heights of metal glory. Mikkey Dee (who would go on to become Motörhead's drummer) works magic on the skins and keeps Abigail's eerie balls in the air alongside Timi Hansen's bass. And then there's King Diamond himself, the man, the myth, the narrator of this spine-chilling tale. Though we may have been forewarned by Mercyful Fate, I don't think anyone was prepared for what KD had in store for us on Abigail. Mid range? Bah! Who needs it? Of course an entire album can be sung in screeching falsetto that makes small children cry. The King has spoken.

And then some:
- King Diamond has been known to use a microphone handle consisting of a femur bone and a tibia bone in the shape of a cross.
- Andy LaRocque owns a recording studio in Varberg, Sweden called Sonic Train Studios.
- Michael Denner owns a record shop in Copenhagen, Denmark called Beat Bop.

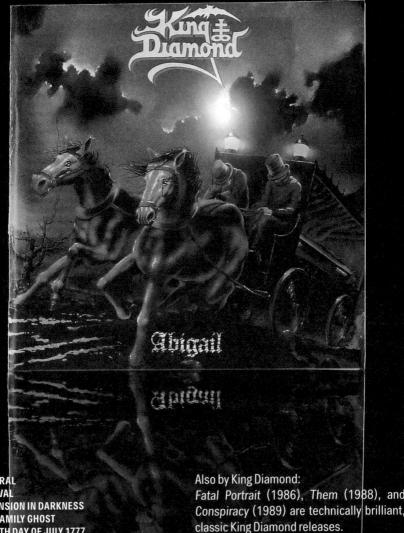

Also by King Diamond:
Fatal Portrait (1986), *Them* (1988), and *Conspiracy* (1989) are technically brilliant, classic King Diamond releases.

KISS
KISS
1974

1974 was an eventful year for metal. Uriah Heep released *Wonderworld*, Judas Priest stepped into the spotlight with *Rocka Rolla*, Deep Purple blew everyone away with *Burn*...and then there was KISS: four dudes from Brooklyn with slightly camp, moderately creepy makeup and copious amounts of sass. It's been reported that after Warner Bros. execs saw the band perform at the *Kiss* launch party, they threatened to cut all ties with record label Casablanca if the boys continued to wear their signature makeup. But the band refused, Casablanca backed them up and now KISS figurines can be seen on the dashboards and mantelpieces of metalheads far and wide.

Majority of material for KISS' debut album was written by Gene Simmons and Paul Stanley during their Wicked Lester years. Though the music was raw and the band unknown, *Kiss* spawned a single (*Nothing to Lose*) and many of the tracks would go on to become concert staples (*Black Diamond, Strutter*). Ace Frehley's frenzied fretting and Gene Simmons' fluid bass lines helped songs like *Deuce* become one of the most covered songs in music history. The album as a whole is tight and catchy and for its time, was heavy as lead. Alice Cooper eat your hear out, KISS mean business and by business I mean fun.

And then some:
• Bathory covered the song *Deuce* on their 1995 album *Octagon*.
• Pantera and Skid Row performed the song *Cold Gin* together during their combined tour in 1992.
• Gene Simmons frequently singed and set his hair alight during his "fire breathing" stage antics.

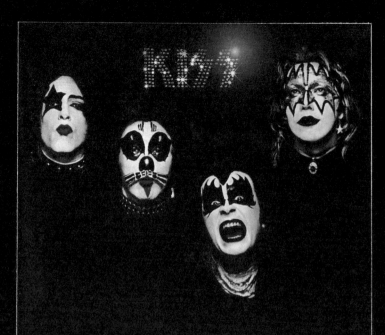

Also by Kiss:
Kiss' live album, the aptly titled *Alive!* (1975), is one of the band's most successful releases. Haven't heard it? One quick spin should explain everything.

KISS
DESTROYER
1976

Picture a guy in demon makeup spewing blood on stage. Awesome. That's the bass player. Imagine his bandmate in spaceman get-up soloing until his guitar explodes. Sweet. Sparks fly from the skins up the back as a cat, yes a cat keeps time. The vocalist smashes his rhythm guitar, betraying the saccharine "starrchild" persona afforded him by yet more make up. They're leather clad and silver studded and the bass player is doing weird things with his abnormally long tongue. Now that is a show.

Love them or hate them, KISS filled arenas and sold records better than most bands could ever dream of doing. They gathered a loyal, occasionally militant army of fans who actively recruited members and railroaded radio stations to get KISS songs on high rotation. What could have inspired such devotion? Three crucial words: *Detroit Rock City*. This anthem along with *God of Thunder, Shout it Out Loud* and *Do You Love Me* will never ever die. Dead-simple and hellishly catchy, producer Bob Ezrin made sure *Destroyer* (unlike KISS' previous albums) would achieve gold, platinum and any other possible metallic accolade. Though some suggest KISS have no place in the heavy metal family, the genre we know and love today was made possible by the solid foundation built by bands like KISS who brought heavy music to the masses and inspired countless bands worldwide.

1. Detroit Rock City (5:17) 2. King Of The Night Time World (3:19) 3. God Of Thunder (4:13) 4. Great Expectations (4:24) 5. Flaming Youth (2:59) 6. Sweet Pain (3:20) 7. Shout It Out Loud (2:49) 8. Beth (2:45) 9. Do You Love Me? (4:57)

PRODUCED BY Bob Ezrin for Migration Records, Inc.

And then some:
- *Destroyer* was the first KISS album to prominently feature outside musicians including the New York Philharmonic-Symphony Orchestra.
- Session musician Dick Wagner (of Alice Cooper) filled in for Ace Frehley on *Flaming Youth, Sweet Pain* and *Beth*.
- Fantasy artist Ken Kelly painted the album artwork for *Destroyer*. Kelly's original cover was rejected by record label Casablanca as the burning buildings pictured in the background were deemed too violent.

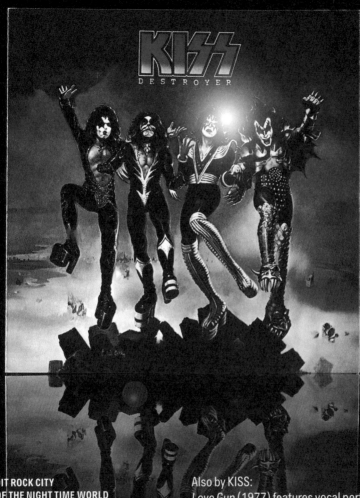

1. DETROIT ROCK CITY
2. KING OF THE NIGHT TIME WORLD
3. GOD OF THUNDER
4. GREAT EXPECTATIONS
5. FLAMING YOUTH
6. SWEET PAIN
7. SHOUT IT OUT LOUD
8. BETH
9. DO YOU LOVE ME
10. (UNTITLED)

Also by KISS:
Love Gun (1977) features vocal performances from all four band members. If you were lucky enough to get an original copy, you would be the proud owner of you very own cardboard "love gun".

KORN

KORN
1994

Fusing hip-hop elements such as rap-inspired vocals with an almost Bungle-style bass, deep, dirty guitars backed by an assault of metal beats, Korn's self-titled debut is energetic, eclectic and difficult to classify in any particular subgenre. As a testament to this, the band is often credited with pioneering the mid-90s trend later dubbed "nu metal", prising open the door for other groups that deviated from the more traditional metal sound to find some mainstream appeal.

Effortlessly shifting from gravelly growling to liquid tones, and often disintegrating into an incomprehensible scat-style percussion, frontman Jonathan Davis' vocal versatility has remained the centrepiece of Korn's intense, schizophrenic sound. The album eventually went platinum and received a well-deserved Grammy nomination. Whether it's the haunting bagpipe overlay of the 9-minute saga that is *Daddy*, the jagged, barely repressed rage of *Divine*, or the chilling nursery rhyme loops that dig under the skin of *Shoots and Ladders*, there's no doubt about it: listening to *Korn* will have you out of your stupor and reaching for your straitjacket in no time.

And then some:
• Korn were featured in a 1999 episode of the satirical animated TV show *South Park*, mimicking the cast of *Scooby Doo*.
• *Korn* contains a hidden track at the end of *Daddy*, which features a man and a woman arguing about fixing a car.

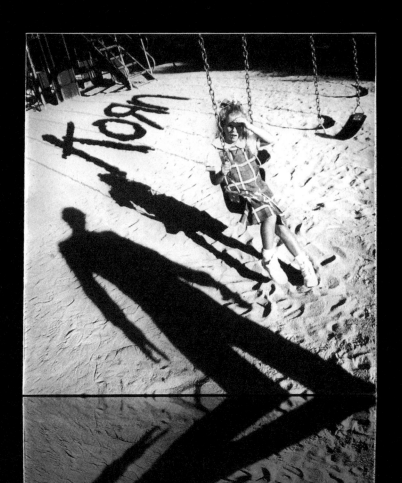

Also by Korn:
Life is Peachy (1999) and *Follow the Leader* (2002) should add some kick to your album collection.

KORN
FOLLOW THE LEADER
1998

The fusion of hip hop and metal has long been a bone of contention for finicky fans of either beloved genre. Very few artists manage to strike a convincing balance between the two without looking foolish to the more discerning musical minds. And then came Korn. Korn's third full-length album, *Follow the Leader* lies somewhere between Neurosis' *Enemy of the Sun*, a Brothers Grimm fairytale, and an obscure eastern European horror film with a South Central L.A. flavour.

The commercial success of this album really belies just how heavy it is. David Silveria absolutely bludgeons his kit on *Got the Life* and *Freak on a Leash*, with each strike of the snare feeling like a mean right hook to the face. Guitarists James "Munky" Shaffer and Brian "Head" Welch spend equal amounts of time at opposing ends of the fretboard to great effect, whilst the hip hop inspired bass of Reginald "Fieldy" Arvizu dances dangerously close to the brown note. Jonathan Davis is clearly a man possessed, displaying equal amounts rage and fragility on tracks such as *Pretty* and *Reclaim my Place*. Limp Bizkit's Fred Durst provides guest vocals on *All in the Family* – a humorous tête-à-tête with Jonathan Davis – and Ice Cube guest stars on *Children of the Korn*. Interspersed with creepy melodies, hip hop rhythms and savage mosh-inspiring breakdowns, *Follow the Leader* is a cohesive, catchy, and above all remarkably accessible album.

And then some:
- The band allegedly spent around $27,000 on alcohol during the recording of *Follow the Leader*.
- *My Gift to You* contains a hidden track –a cover of Cheech and Chong's *Earache My Eye*.

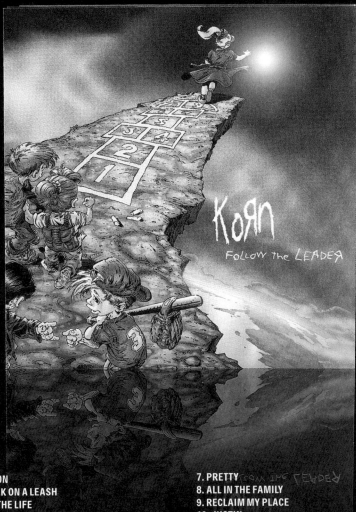

1. IT'S ON
2. FREAK ON A LEASH
3. GOT THE LIFE
4. DEAD BODIES EVERYWHERE
5. CHILDREN OF THE KORN
6. B.B.K

7. PRETTY
8. ALL IN THE FAMILY
9. RECLAIM MY PLACE
10. JUSTIN
11. SEED
12. CAMELTOSIS
13. MY GIFT TO YOU

Also by Korn:
Look out for *Issues* (1999).

KREATOR
PLEASURE TO KILL
1986

Obviously, with a name like *Pleasure to Kill*, Kreator never meant this album to be a light-hearted exploration of acid jazz. This album was intended to thrash your face off. Mindless brutality, feral musicality...this is not an album for anyone who needs a sing-along chorus or a catchy beat. Kreator's approach to writing thrash songs broke the mould in 1986. Alongside Slayer's *Reign in Blood* and Dark Angel's *Darkness Descends*, Kreator's sophomore release created the thrash wellspring from which majority of succeeding thrash bands would siphon inspiration.

From Jürgen "Ventor" Reil's intensely violent drum work to the gritty, sadistic dual vocals, *Pleasure to Kill*'s aggressive wall of sound flattens everything in its path. You can try to bang your head, you can attempt a defiant fist in the air, but even the most solid thrasher may find this album to be very nearly indigestible. Nearly, but not quite. The incessant barrage of musical depravity moves within the confines of nine (twelve if you have the re-master) distinguishable tracks. The song structures are tight, the writing is creative and the musicianship is spot on. It may catch in your throat like a chicken bone, but *Pleasure to Kill* is worth every splutter, every heave.

And then some:
- Kreator formed in 1982 under the name Tormentor.
- *Pleasure to Kill* was produced by Harris Johns who has also worked with Helloween, Coroner, Tankard, Voivod and Sodom among many others.
- Kreator recorded their debut album *Endless Pain* in just 10 days.

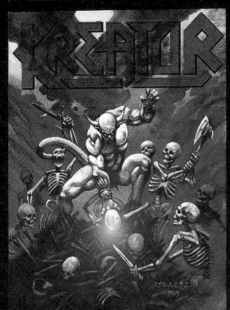

pleasure to kill

pleasure to kill

Also by Kreator:
Without mentioning the entire discography, you'd do well to flesh out the thrash section of your collection with *Terrible Certainty* (1987), *Extreme Aggression* (1989), *Violent Revolution* (2001) and *Hordes of Chaos* (2009).

LAMB OF GOD
SACRAMENT
2006

"Mom, I'm starting a band called Burn the Priest". Now there's a moment in metal history worthy of a You Tube posting. On that fateful day in Richmond, Virginia, Chris Adler, Mark Morton and John Campbell plotted their course to metal glory. After a number of demos, a self-titled LP and crucial line-up changes, Burn the Priest became Lamb of God and heads began to turn.

Lamb of God's first three albums were good. *New American Gospel* earned the band comparisons with Pantera and nods from critics. *As the Palaces Burn* was voted the number one album of 2003 by *Revolver* and *Metal Hammer*. *Ashes of the Wake* scored the band a slot at Ozzfest and Sounds of the Underground and another thumbs up from *Revolver*. In the midst of their meteoric rise, Lamb of God decided to take a giant leap away from their winning formula and released *Sacrament* – a melancholic, atmospheric masterpiece. The classic LOG aggression is still there, and this album is no less heavy than their previous releases, but the sound is refined and sophisticated. Randy Blythe's vocals are perfectly suited to the spiteful, poetically venomous lyrics. Shredtastic guitars and Chris Adler's punishing drum work show the boys have been doing their homework in the two years between releases. Whatever your metallic leanings, you'll love this album.

And then some:
• Burn the Priest was formed in 1990 as an instrumental group.
• Randy Blythe was a guest vocalist on *Adoration for None* from Gojira's 2008 album *The Way of All Flesh*.
• Guitarist Willie Adler has a tattoo of a southern fried chicken dinner on his stomach.

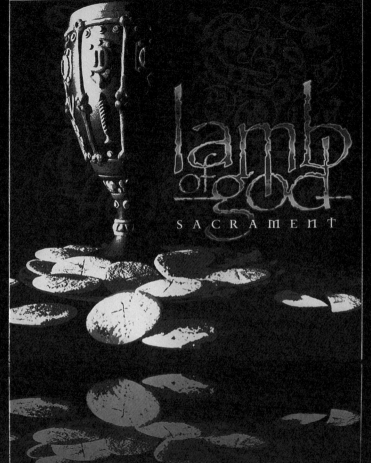

1. WALK WITH ME IN HELL
2. AGAIN WE RISE
3. REDNECK
4. PATHETIC
5. FOOT TO THE THROAT
6. DESCENDING
7. BLACKEN THE CURSED SUN
8. FORGOTTEN (LOST ANGELS)
9. REQUIEM
10. MORE TIME TO KILL
11. BEATING ON DEATH'S DOOR

Also by Lamb of God:
Ashes of the Wake (2004) is a quality release, which spawned two singles: Laid to Rest and Now You've Got Something to Die For.

MACHINE HEAD
THE BLACKENING
1987

Depending on whom you speak to in the metal community, Machine Head lie somewhere between bandwagon jumpers, sell-outs, and heavy metal gods. Over the years they have been on the receiving end of much criticism for the choices they've made, both musically and visually. Since the release of their bone-crunching 1994 debut *Burn My Eyes*, they have dabbled in rap, hardcore, nu metal, the odd ballad, and even a cover of *Message in a Bottle* by The Police. At the turn of the millennium, some started to question their relevance to the heavy metal genre.

In 2007, however, Machine Head gave their fans, peers, and detractors a severe and unforgettable lesson in metal. There is only one word to describe every aspect of this album: epic. The songs are ambitious and complex, yet without a hint of bombast or repetition. The jaw-droppingly flawless guitar work of Rob Flynn and Phil Demmel on tracks like *Aesthetics of Hate* and *Slanderous* will leave your head throbbing in excruciating ecstasy. Dave McClain and Adam Duce's rhythm section could summon enough devastating power to send Charles Richter back to the drawing board. Flynn leaves you in no doubt that he is still an angry man, but the lyrical themes suggest his anger has matured into a vehicle for positive change, rather than just an expression of indiscriminate rage. This is without a doubt Machine Head's opus – an opus that firmly cemented their place among the heavy metal elite.

And then some:

• The US special edition includes cover versions of Iron Maiden's *Hallowed Be Thy Name* and Metallica's *Battery*.

• The song *Aesthetics of Hate* was written in response to an article entitled *Aesthetics of Hate: R.I.P. Dimebag Abbot, and Good Riddance* by conservative columnist William Grim.

MACHINE HEAD

THE BLACKENING

THE BLACKENING

PARENTAL ADVISORY EXPLICIT CONTENT

1. CLENCHING THE FISTS OF DISSENT
2. BEAUTIFUL MOURNING
3. AESTHETICS OF HATE
4. NOW I LAY THEE DOWN
5. SLANDEROUS
6. HALO
7. WOLVES
8. A FAREWELL TO ARMS

Also by Machine Head:
Burn My Eyes (1994) is a must own, as is their sophomore album The More Things Change... (1997)

MARILYN MANSON
ANTICHRIST SUPERSTAR
1996

It's strange to think of a Marilyn Manson who was genuinely shocking, and not just a caricature of metal's worst excesses. But back in 1996 the very mention of his name was enough to set parents and school teachers' teeth on edge. His landmark second album Antichrist Superstar was an ambitious concept album (the first of three), detailing the story of the miserable title character's rise to superstardom, before assuming the position of a virtual anti-God.

Such a pretentious start belies the quality and consistency beneath the shock tactics. Twiggy Ramirez as primary song writer is on top of his game, and the sixteen songs on show are dark, aggressive and surprisingly catchy for such a nightmarish soundscape. The variety is impressive. Note the staccato guitars, marching band percussion and amazingly catchy main riff of the lead single (and Manson's biggest hit) The Beautiful People; the thrash metal stylings in Irresponsible Hate Anthem; and the grandiose anthems of The Reflecting God and the title track. Manson whispers, shouts, screams and growls throughout the whole sordid journey to the delight of fans and the horror of grownups. A solid underlying pop sensibility keeps the album accessible without compromising lyrically or musically on its dark subject matter.

 While not the album to find epic guitar solos or a barrage of riffs, it's an example of confident songwriting, lyricism and theatrics combining for a supremely satisfying listen. Whatever has become of Marilyn Manson, Antichrist Superstar is a seriously fun record.

And then some:
• The opening track Irresponsible Hate Anthem is listed in the liner notes as being recorded live in February 1997, despite the album being released almost six months earlier.
• The CD version of the album actually has tracks programmed all the way up to 99 (culminating in a secret track), frustrating random play enthusiasts everywhere.
• The original cover was banned by many record stores, resulting in the record being shipped in an alternate slipcase.

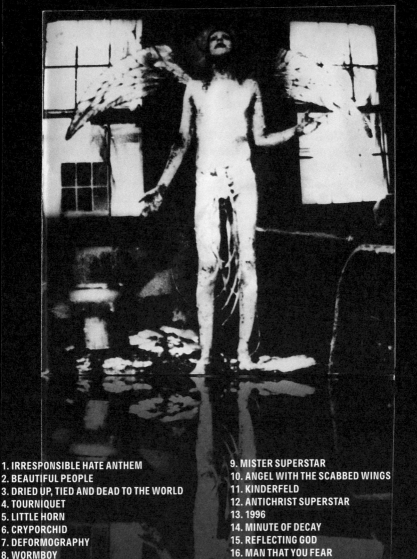

1. IRRESPONSIBLE HATE ANTHEM
2. BEAUTIFUL PEOPLE
3. DRIED UP, TIED AND DEAD TO THE WORLD
4. TOURNIQUET
5. LITTLE HORN
6. CRYPORCHID
7. DEFORMOGRAPHY
8. WORMBOY

9. MISTER SUPERSTAR
10. ANGEL WITH THE SCABBED WINGS
11. KINDERFELD
12. ANTICHRIST SUPERSTAR
13. 1996
14. MINUTE OF DECAY
15. REFLECTING GOD
16. MAN THAT YOU FEAR
17. UNTITLED (HIDDEN TRACK)

Also by Marilyn Manson: Though a prominent departure from the dark and gothic sound of *Superstar*, the follow up album *Mechanical Animals* (1998) is a drug obsessed electro/industrial bad acid trip, and well worth your time.

MASTODON
LEVIATHAN
2004

Mastodon are one of those bands whose very existence ensures the future of metal is an honourable one. Since they emerged in 2002 with Remission, Mastodon have outshone and outclassed their starry-eyed cohorts in the "New Wave of American Heavy Metal" scene. With flagrant disregard for subgenres and the territorial confines of modern day metal, their sound is stunningly authentic and all-encompassing. Troy Sanders, Brent Hinds, Bill Kelliher and Brann Dailor formed Mastodon in 1999 and haven't put a foot wrong yet.

When Leviathan dropped in 2004, it levelled the metal landscape. Its short-term effect was to render the hackneyed, passionless bands (past and present) obsolete. Its effects on heavy metal music in general are still reverberating around the scene, inspiring talented upandcommers like Baroness to make intelligent music for discerning fans. As a concept album, Leviathan is born of grand inspiration: Herman Melville's Moby Dick. The story is told through heavy sludge grooves tempered with striking melodies working within meticulously crafted songs. It's an elegant mixed-bag of pure metal and one of the best albums to ever grace the scene.

And then some:
• Leviathan won Album of the Year awards from Revolver, Kerrang! and Terrorizer magazines.
• The cover art for Leviathan was designed by Paul A. Romano.
• Brent Hinds and Bill Kelliher won the Metal Hammer Golden Gods award for best shredders.

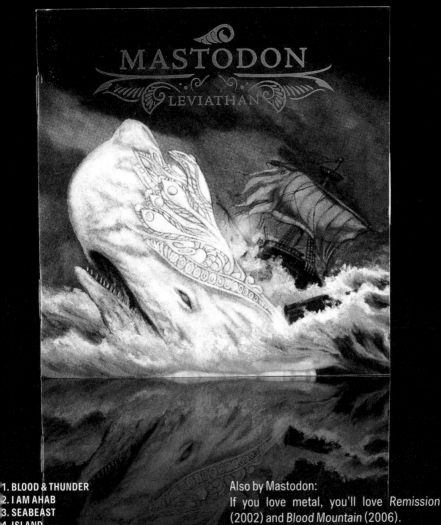

MASTODON

LEVIATHAN

Also by Mastodon:
If you love metal, you'll love *Remission* (2002) and *Blood Mountain* (2006).

MAYHEM
WOLF'S LAIR ABYSS
1997

Mayhem –who along with bands such as Burzum, Darkthrone, Immortal and Emperor formed the infamous vanguard of Norwegian black metal – are no strangers to controversy. Much like KISS decades before them, their sound, image and over the top live performances helped spread the word that something new, incredible, and oh so evil was happening in the music world. After the well publicised murder of founding member and guitarist Euronymous (Øystein Aarseth) by former band mate and Burzum founder Varg Vikernes, the new Mayhem line-up entered the studio to record the Wolf's Lair Abyss EP, which was later described by the band as part 1 of the full-length follow up *Grand Declaration of War*.

Wolf's Lair Abyss opens with *The Vortex Void of Inhumanity* –a collection of sci-fi sound effects combined with a Borat-esque voiceover which should have been left off this release as it adds nothing to the EP overall. The next 4 tracks, however, are nothing short of the most ferocious and unrelenting black metal ever committed to tape. The production of this album is relatively polished, when compared with the recorded-in-a-wine-cellar-on-a-Fisher-Price-tape-recorder production values of Darkthrone's earlier work. The incendiary drumming of Hellhammer (Jan Axel Bloomberg), whose fluid double kicking is reminiscent of Morbid Angel's Pete Sandoval, combined with the trance inducing axe work of Blasphemer (Rune Eriksen), and the inhuman, rasping vocals of Maniac (Sven Erik Kristiansen) make for uneasy yet required listening.

And then some:
• Mayhem's 1994 album *De Mysteriis Dom Sathanas* is unique in the fact that murderer (Vikernes) and victim (Euronymous) perform together.

• In 2003, a fan suffered a fractured skull after a sheep's head flew off stage during a live Mayhem show. The fan later sued Mayhem, saying he now has an ambivalent relationship with sheep.

• Former vocalist Dead (Per Yngve Ohli), committed suicide during the writing of *De Mysteriis Dom Sathanas*. A photo of his corpse was later used on the cover of the live bootleg *Dawn of the Black Hearts* (1995).

wolf's lair abyss

Also by Mayhem:
The cult classic *Deathcrush* (1987) and the widely acclaimed *De Mysteriis Dom Sathanas* (1994) are essential black metal records.

MEGADETH
RUST IN PEACE
1990

From the opening riff of *Holy Wars* through to the final bombastic closer Rust in Piece...Polaris, this album captivates like a giant sweaty fist around your throat. Though Megadeth are known for their ever-changing line-up, *Rust In Piece* is performed by the dream team: Dave Mustaine and Marty Friedman on guitar, David Ellefson on bass and Nick Menza on drums. What they've created here is a technically proficient, classic goodie-bag of an album. *Rust In Piece* has it all; incredible riffs, strong vocal melodies, intriguing lyrics, stunning lead work, a great sound and nine unforgettable tracks.

Recruiting Nick Menza was one of Megadeth's smarter decisions. His work on this album is immaculate, heavy when needed, maturely controlled with a decent amount of swing. Fantastic as he is, *Rust in Piece* is widely considered a guitar record. Mustaine and Friedman work together in inconceivable harmony on this album. *Hangar 18* features a breathtaking series of guitar attacks traded effortlessly between the two consummate axe men. The opening riff in *Take No Prisoners* still stands as some of metal's most intense guitar work, and the speedy, punky thrash of *Poison Was The Cure* is a definite favourite of wannabe slingers across the globe. The classical interlude on *Holy Wars... The Punishment Due* sets the standard for all past and present Megadeth guitarists (of which there will probably be many), as does the beautiful, graceful solo from *Tornado of Souls*. *Rust in Piece* is a record every metal guitarist should own.

And then some:
• The album was re-mastered and re-released in 2004, including one unreleased and three demo tracks.
• Dave Mustaine once said "I like to play the stuff that makes you say, 'How does he do that and sing?'"
• Megadeth was formed by Dave Mustaine as revenge against Metallica who fired him for drinking, drug use, violence and personality conflicts.

Also by Megadeth:
Countdown to Extinction (1992) is the follow up to *Rust in Peace* and Megadeth's best selling album. *Peace Sells... But Who's Buying?* (1986) is also a classic metal album worth checking out.

MERCYFUL FATE
DON'T BREAK THE OATH
1984

All hail Satan, or rather, his amusing theatrical counterpart: King Diamond. Like an Olympic athlete, Diamond took the metal torch from Iron Maiden and Judas Priest and ran with it all the way into the unknown. *Don't Break the Oath* was well ahead of its time when it dropped in 1984. In terms of musical proficiency, Diamond, Denner, Shermann, Hansen and Ruzz were an infallible ensemble for whom world domination was a definite possibility. Though *Don't Break the Oath* brought the promise of a new (musical) world order to metal fans, the dream team disbanded after this album and we were left with the needle scratching and our hopes dashed.

But we still had this, one of the greatest extreme metal albums of all time. Before blastbeats and double bass pedals, before pig squeals and incoherent guttural growls, there was atmosphere. Mercyful Fate's lyrics are full of occult themes and Satanic references: *Tonight the circle is broken forever/ Seven people dead within a trance/ In here nobody is sensing the rain/ Tonight seven souls are reaching hell*. By today's standards (I'm sensing the derisive laughter of Cannibal Corpse fans), such poetics may seem a little soft. But King Diamond's angel-of-death-raining-terror-upon-thee piercing falsetto makes it all seem scarily plausible. The Princess of Hell may well be on her way. The spirits of the unborn might actually play tonight. Mercyful Fate were frightening fans before "Corpsegrinder" had even heard the word "necrophilia".

And then some:
- Mercyful Fate reunited in 1992 and released six subsequent albums.
- "Melissa" is the name of a human skull that King Diamond took with him on stage.
- King Diamond was born Kim Bendix Petersen on June 14, 1956 in Copenhagen, Denmark.

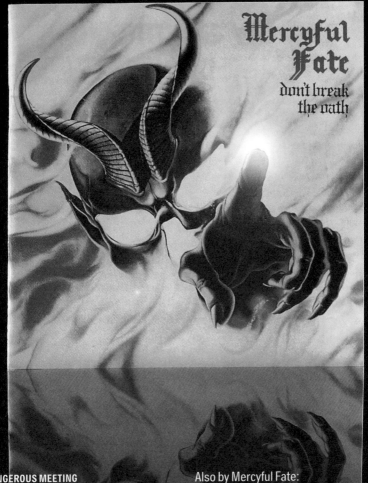

Mercyful Fate
don't break the oath

1. A DANGEROUS MEETING
2. NIGHTMARE
3. DESECRATION OF SOULS
4. NIGHT OF THE UNBORN
5. THE OATH
6. GYPSY
7. WELCOME PRINCESS OF HELL
8. TO ONE FAR AWAY
9. COME TO THE SABBATH

Also by Mercyful Fate:
Melissa (1982) is an essential purchase for any Mercyful Fate/King Diamond fan.

MESHUGGAH
DESTROY ERASE IMPROVE
1995

Destroy Erase Improve was an album that set out to redefine the spheres of thrash and industrial metal. Lofty ambitions indeed, but Meshuggah are Swedish and heavy metal virtuosity (as studies have shown) is intrinsic to Scandinavians. Of course they would do it and do it well. With jazz fusion guitar solos, polyrhythmic drumming and each instrument frequently playing to separate time signatures, their vision for this album was a theoretical dog's breakfast. Through a combination of brutal but minimalist songwriting and technical mastery, *Destroy Erase Improve* is awe inspiring without being overpowering. Above all the songs are smart, and know when to hold back on the histrionics and when to let everything go for a full out assault. Much of the drumming and guitar riffs sound almost effortless at first, but at second glance are deviously complex and delivered with military precision. The drill sergeant vocals tie in perfectly.

Meshuggah take metal apart piece by piece and remake it to their own unique vision, embodying the album's lyrical themes of man and machine evolving into new forms. Experimental, devastating and technical in equal parts, *Destroy Erase Improve* is one of the most influential metal albums of the 90s. As well as inspiring innumerable bands, it was the springboard from which Meshuggah would continue their metallic exploration through a career that continues to break the boundaries of what metal can achieve.

And then some:
• In 2007, Meshuggah's unconventional musical approach and technical mastery was rewarded with an in-depth article in the academic journal *Music Theory Spectrum*.
• Meshuggah was formed by guitarist Fredrik Thordendal in Umeå in 1985 under the name Metallien.
• Tomas Haake was named number one in the metal category in *Modern Drummer* magazine's 2008 Reader's Poll.

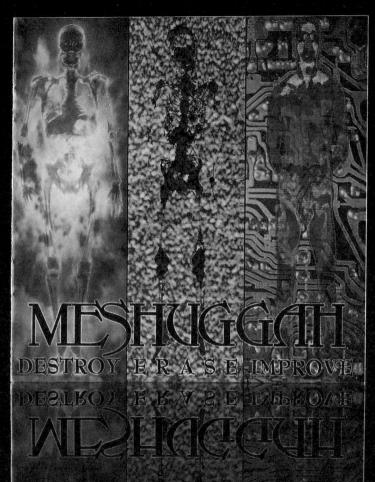

MESHUGGAH
DESTROY ERASE IMPROVE

Also by Meshuggah: Meshuggah's follow up album *Chaosphere* (1998) dropped many of the jazz fusion elements, but what it loses in experimentation it makes up for in crushing intensity. On the other end of the scale, their latest record *ObZen* (2008) provides an effective culmination of all the elements of previous albums.

METALLICA
RIDE THE LIGHTNING
1984

To truly understand what Metallica is all about, you have to listen to *Fade To Black*: *"I have lost the will to live / Simply nothing more to give /There is nothing more for me /Need the end to set me free"*. Metallica are known (and adored) for not pulling any punches or wallowing in the teen angst that forms the basis of many a crappy pop-metal release and as such, this track may have you scratching rather than banging your head. Why so glum boys? As the story goes, some handsy sucker in Boston stole Metallica's equipment following a gig in early 1984. Not just a handful of plectrums to hock on Ebay, we're talking The Lot. So yes, Hetfield may have felt suicidal or at least a little blue, hence the dark and broody lyrics. And that's pure Metallica: reactionary, honest and pissed off.

Ride The Lightning is Metallica's second studio album –and what an album it is. *For Whom The Bell Tolls* is a fan favourite for its heavy, pit-perfect drive and there's not a Metallica disciple alive who doesn't enjoy the sweet satisfaction of whiplash after listening to the speedy *Trapped Under Ice*. If you don't have hair long enough to show the kind of appreciation that *Ride The Lightning* demands, buy a wig. Now, come on, scream with me: *"Die by my hand / I creep across the land / killing first born man..."*

And then some:
- *For whom The Bell Tolls* pays homage to Ernest Hemingway's novel of the same name.
- James Hetfield's guitar enhancer that was stolen in Boston was a gift from his mother. She passed away from cancer shortly after giving it to him.
- *The Call Of Ktulu* won a Grammy in 2001 for Best Rock Instrumental Performance. About time too.

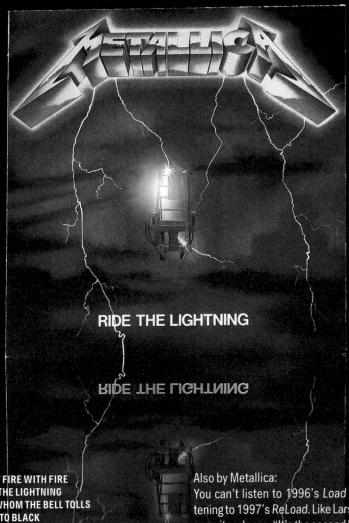

RIDE THE LIGHTNING

RIDE THE LIGHTNING

1. FIGHT FIRE WITH FIRE
2. RIDE THE LIGHTNING
3. FOR WHOM THE BELL TOLLS
4. FADE TO BLACK
5. TRAPPED UNDER ICE
6. ESCAPE
7. CREEPING DEATH
8. THE CALL OF KTULU

Also by Metallica:
You can't listen to 1996's *Load* without listening to 1997's *ReLoad*. Like Lars Ulrich said upon its release, "It's the second half of Load. It's just coming out a year and a half later".

METALLICA
MASTER OF PUPPETS
1986

Master of Puppets is listed in the book *1001 Albums You Must Hear Before You Die* and just about every other book/list/article/internet forum about the best heavy metal albums of all time. Of course there will always be a few contrary souls who will feel compelled to whisper the word "overrated" whilst wrapped in the fluffy pink blanky of anonymity. They are obviously wrong, but such high praise does warrant an explanation.

Master Of Puppets is largely considered Metallica's masterpiece, the band's *Sgt Peppers* if you will. Without giving credence purely to fans and critics (let it be that they are unanimous on this), Metallica themselves have agreed that this album is indeed the pinnacle of their career, calling it their magnum opus. Free of all the cloak and dagger, "Satan rules!" pissing contests, *Master of Puppets* is nothing but pure pared down metal. Pity the fool who searches for metaphors and escapist drivel in the guileless simplicity offered here. Simple yes, dull: never. The tracks average somewhere around the seven minute mark, that's seven minutes of pounding metal multiplied by eight impeccably crafted songs which equals just under 55 minutes of heavy metal perfection. Hammet, Hetfield, Ulrich and Burton slug out the classics like a well-oiled machine...this may just be the heavy metal handbook.

And then some:

• *Master Of Puppets* is the last Metallica album to feature Cliff Burton on bass. Burton was killed in a bus accident in Sweden in September 1986.

• Many prints of this release featured the warning "The only track you probably don't want to play is *Damage, Inc.* due to the multiple use of the infamous "F" word. Otherwise, there aren't any shits, fucks, pisses, sucks, cunts, motherfuckers or cocksuckers anywhere on this record".

• *The Thing That Should Not Be* is based on H.P. Lovecraft's horror stories.

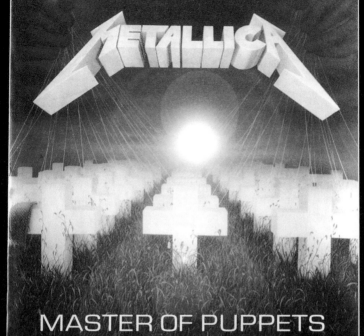

MASTER OF PUPPETS

PolyGram

BATTERY
MASTER OF PUPPETS
THE THING THAT SHOULD NOT BE
WELCOME HOME (SANITARIUM)
DISPOSABLE HEROES
LEPER MESSIAH
ORION
DAMAGE, INC.

Also by Metallica:
Load (1996) boasts Metallica's longest
studio recording (78:59) and includes the
standouts Until it Sleeps and King Nothing.

METALLICA
. . .AND JUSTICE FOR ALL
1988

It's a movie from 1979, starring Al Pacino. Never seen it? Doesn't matter. It's the last line in the Pledge of Allegiance. Never read it? Whatever. It's a Metallica album. Never listened to it? You're either a small child with cruel parents or you were tragically born without ears. Either way, your musical future is in peril. *...And Justice For All* is considered Metallica's breakthrough album, and with good reason: the fourth track is One. That pretty much says it all. No wonder all hell broke loose when it didn't receive a Grammy in 1989. On top of that, it was Jethro Tull's Crest Of A Knave they lost it to. That had to hurt.

The sound on *...And Justice for All* differs from Metallica's previous three studio albums in that there's a significant lack of bass guitar and more of an acoustic-like sound. The tracks revel in the typical metal fodder of injustice, war, hate and insanity –seemingly endless pits of inspiration. When explaining why *...And Justice for All*'s beloved tracks are never played on tour, Kirk Hammett summed it up with "the songs are too fucking long". Fair point. With the shortest cut reaching a little over 5 minutes, this is more an album for a fan to sit at home and revel in while clutching your air Stratocaster and screaming in what you believe to be "perfect pitch". Although this is Metallica's first studio album with Jason Newsted on bass (and a fine job he does too), Cliff Burton's spirit still lives on in *To Live Is To Die*: a track written in his honour. Respect.

And then some:
• *One* was the first Metallica track to spawn a music video.
• It took 16 years after recording until *Dyers Eve* was performed live in its entirety (during the *Madly In Anger With The World* tour).
• The guitar solo in *One* is ranked #7 in *Guitar World's* "100 Greatest Solos Of All Time".

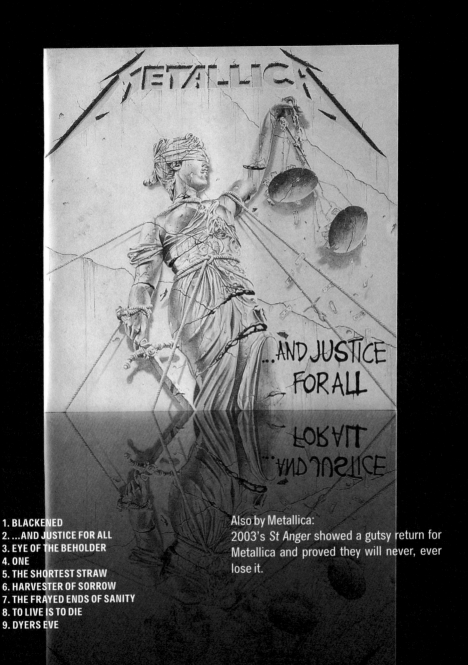

METALLICA

...AND JUSTICE FOR ALL

Also by Metallica:
2003's *St Anger* showed a gutsy return for Metallica and proved they will never, ever lose it.

METALLICA
METALLICA
(A.K.A. THE BLACK ALBUM)
1991

Oh sweet Jesus. *Enter Sandman, Nothing Else Matters, Sad but True, Wherever I May Roam, The Unforgiven...* my hands are shaking. Years from now when the music world has sunk into the cheerless bog of trial-by-radio, our children's children are going to marvel at how one album (all those years ago) could have contained so many luminous songs, singles no less!

Tighter than *Justice*, more diverse than *Master of Puppets*, Metallica differs completely from the band's previous studio albums in terms of sound, lyrics and above all: the green. By 1991, Metallica was a cash cow, which to a confused metal faction meant but one thing: they had sold out. Metallica purists brandished torches and pitchforks and renounced the album as commercial waste while the rest of us saw it for what it was and still is today: totally freaking awesome. Yes, it has a more accessible tempo than their other releases; each cut is feverishly catchy and noticeably less aggressive. But the fact that the general public (even those not born with metal pulsing through their veins) embraced this album is the mark of undeniable musical perfection rather than a dumbing down of metal sensibilities. If you don't love this album, if you don't scream along like the millions before you with at least the opening lines of *Enter Sandman*, you are dead inside.

And then some:

• *The God That Failed* describes how James Hetfield dealt with losing his mother to cancer.

• This was the first time that Metallica worked with Michael Kamen, who arranged the orchestration on *Nothing Else Matters*. As we all know, they later performed together recording S&M in 1999, in which Kamen conducted the San Francisco Symphony Orchestra.

• The snake on the album cover is derived from the Gadsden flag, along with the motto Don't Tread On Me. Yes, just like the title of the song.

Also by Metallica:
2008's *Death Magnetic* was Metallica's fifth studio album to debut at number one on the Billboard 200. This album shows Metallica in top form with some nice touches from Rick Rubin.

MONSTER MAGNET
POWERTRIP
1998

As the story goes, pill-popping white-trash hedonist Dave Wyndorf gets off the *Dopes to Infinity* tour determined to write an album's worth of material. He heads to that cesspit of inspiration –Las Vegas– and holes himself up in a hotel room. Twenty-one days later, Wyndorf emerges from his den of iniquity clutching twenty-one sleaze metal classics in his sweaty fist –thirteen of which would become *Powertrip*. Lust, greed, decadence and moral decay form the thematic basis of the album, and one couldn't expect anything less from either Wyndorf or Vegas. The lyrics are charmingly grimy: *Sucking love from wherever I can/ Cashing Satan's checks with my dick in my hand* (3rd Eye Landslide); *I saw his girlfriend's face in a bucket of water / He said a buck for the snatch and a nibble a quarter*. Awesome.

The music itself sees Monster Magnet's signature psychedelic stoner rock take on a more metallic sheen. *Powertrip* is more aggressive and mature than their previous releases, sounding almost Black Sabbath-ish in execution. Monster Magnet's loud-catchy-obnoxious formula is retained through big fat power chords and thunderous drum fills, but the occasional ballad is thrown in to give the album some depth. This delightfully squalid, sludge-encrusted hell-ride through Dave Wyndorf's depraved imagination is a trip worth taking.

And then some:
- The name Monster Magnet was taken from a toy produced by Wham-O in the 1960s.
- The title track from *Powertrip* was used as the official theme song for the WWE No Way Out pay-per-view event.

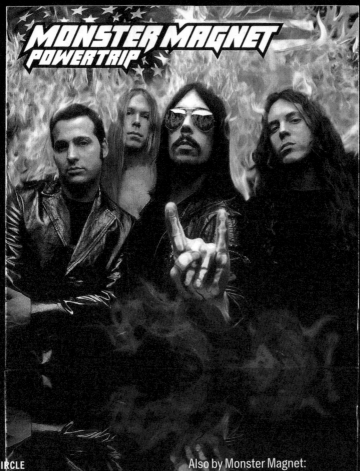

MONSTER MAGNET
POWERTRIP

Also by Monster Magnet:
Dopes to Infinity (1995) and *Monolithic Baby!* (2004) are essential Monster Magnet albums.

MORBID ANGEL
BLESSED ARE THE SICK
1991

Let's have a crack at some heavy metal free association: I say "American death metal", you, naturally, say "Morbid Angel". If I spin it around and say "Morbid Angel", your options are suddenly broadened to an extent beyond the realm of traditional death metal. Mozart, jazz great Miles Davis...their influences come from far and wide. Through Morbid Angel's 25 plus year career, this Florida trio has proven their compositional proficiency to be on a level that far surpasses that of their metal contemporaries. Labyrinthine arrangements, unconventional time signatures, atonal riffing combined with an uncompromising and fastidious approach towards their music have become Morbid Angel's modus operandi.

The opening track *Fall from Grace* weaves its way from a machine-like stomp through to rapid-fire blastbeats, before slowing to a mid-paced tempo then racing back up again with Trey Azagthoth's mind-boggling solos to top it all off. The mid-paced theme continues on *Day of Suffering* and *Blessed Are the Sick/Leading the Rats*, whilst the speed and technical prowess for which Morbid Angel is renowned is displayed on tracks like *Thy Kingdom Come* and *Unholy Blasphemies*. Instrumental compositions such as *Doomsday Celebration, Desolate Ways* and the medieval *In Remembrance* add another dimension to the mood of this landmark album. It's all about layers.

And then some:
- The cover artwork is a painting by Jean Delville entitled *Les Tresors de Satan*, which was also used by Hexenhaus for their 1988 album *A Tribute to Insanity*.
- Trey Azagthoth is a keen fan of Japanese anime, and video games such as the *Quake* series and *Metal Gear Solid*.
- Morbid Angel are the third highest selling death metal band of all time.

Also by Morbid Angel:
Hunt down *Alters of Madness* (1989), *Covenant* (1993), and just for something different, 1994's *Laibach Remixes*.

MÖTLEY CRÜE
SHOUT AT THE DEVIL
1983

The word "Satanist" is bandied around ridiculously often when it comes to heavy metal. Since the genre took form in the early 70s, phrases such as "Devil worshipers" and "members of the Occult" have been used to describe bands who refuse to even curse, let alone espouse Beelzebub's leadership skills. Perhaps the most amusing accusation was made in 1983 upon the release of *Shout at the Devil*, Mötley Crüe's fifth studio album. Yes, the music is heavy and the lyrics dark, but really? The massive hair, the lipstick and rouge, figure hugging shredded leather get-up? A motley crew with out a doubt, but Satanists? Either way, the publicity was priceless.

Just about everyone you know owns this album right? It's one of those metal mainstays without which a collection could tumble into the tepid waters of superficiality. It's sex, drugs, violence and rebellion drenched in distortion and glam metal power. Shout-along choruses, killer hooks and solid beats are present throughout, and inspired tempo changes (the Judas Priest-ish *Red Hot* is fierce) keep things interesting. *Shout at the Devil* is the quintessential 80s heavy metal album. If you don't own it you should. If you do, turn it up.

And then some:
- Tommy Lee and Vince Niel attended high school together at Royal Oak H.S. in Covina.
- Nikki Sixx was born Frank Carlton Serafino Feranna Jr.
- The band released a collective autobiography entitled *The Dirt: Confessions of the World's Most Notorious Rock Band* published in 2001.

MÖTLEY CRÜE

SHOUT AT THE DEVIL

SHOUT AT THE DEVIL

1. IN THE BEGINNING
2. SHOUT AT THE DEVIL
3. LOOKS THAT KILL
4. BASTARD
5. GOD BLESS THE CHILDREN OF THE BEAST
6. HELTER SKELTER [BEATLES COVER]
7. RED HOT
8. TOO YOUNG TO FALL IN LOVE
9. KNOCK 'EM DEAD, KID
10. TEN SECONDS TO LOVE
11. DANGER

Also by Mötley Crüe:
Too Fast for Love put the Crüe on the map in 1982 and is well worth a spin.

MOTÖRHEAD
ACE OF SPADES
1980

Despite Lemmy's ardent refusal to be categorised as heavy metal "we are Motörhead, we play rock n roll", the horn wielding masses have claimed the British trio like Kenya claimed Obama—rightfully so. Motörhead did so much for metal, pioneering speed and thrash and unapologetic heaviness. With a catalogue dating back to 1977, Lemmy, Fast Eddie and Philthy Animal transposed their raging white line fever onto a series of unforgettable albums. *Ace of Spades* dropped in 1980, one of the most important years in heavy metal history. Iron Maiden released their eponymous album, Judas Priest unleashed *British Steel*, AC/DC came out with *Back in Black* and Ozzy Osbourne gave us *Bark at the Moon*. Despite the crowded scene and an intimidating peer group, Motörhead's fourth album stood up to be counted and hasn't left the limelight since.

Fast, meaty riffs and superlative songwriting abound in this filler-less metal milestone. Killer tracks like *The Chase is Better than the Catch* and the classic *(We Are) The Road Crew* beg to be played at deaf-defying volume, at least once a week. Each of the twelve tracks is rude, obnoxious and in-your-face, just the way it should be. If you're unsure of Motörhead's significance to metal or their ability to produce achingly-good anvil-weighted music, *Ace of Spades* will beat you into submission.

And then some:

• Lemmy once worked as a roadie for The Jimi Hendrix Experience.

• Phil Taylor and Fast "Eddie" Clark met while working on a houseboat.

• Lemmy claims he was sacked from Hawkwind for "doing the wrong drugs".

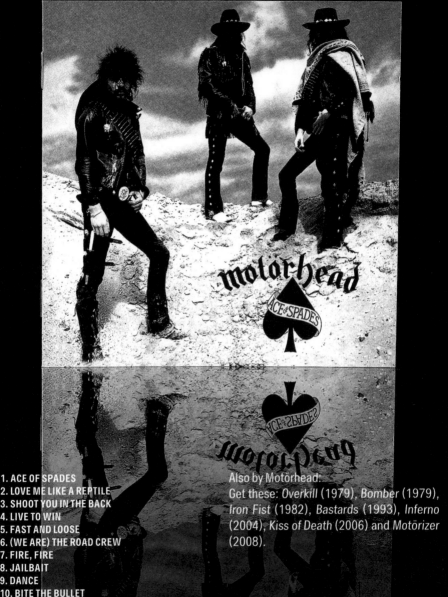

1. ACE OF SPADES
2. LOVE ME LIKE A REPTILE
3. SHOOT YOU IN THE BACK
4. LIVE TO WIN
5. FAST AND LOOSE
6. (WE ARE) THE ROAD CREW
7. FIRE, FIRE
8. JAILBAIT
9. DANCE
10. BITE THE BULLET
11. THE CHASE IS BETTER THAN THE CATCH
12. THE HAMMER

Also by Motörhead:
Get these: *Overkill* (1979), *Bomber* (1979), *Iron Fist* (1982), *Bastards* (1993), *Inferno* (2004), *Kiss of Death* (2006) and *Motörizer* (2008).

NAPALM DEATH
UTOPIA BANISHED
1992

There aren't many bands that can be credited with pioneering an entire musical genre. Napalm Death managed to do that simply by coining the term "grindcore" to describe their particularly vicious blend of thrash metal and hardcore. After flirting heavily with death metal on their previous two albums, the Birmingham quintet's fourth record saw them take a few steps back to their grind roots whilst still moving ever forward in terms of songwriting.

From its creepy spoken word intro to the epic (by their standard anyway, it clocks in at a little over 4 minutes) final track, *Utopia Banished* is 39 minutes of throat-slitting aggression and flat out power. It does offer the occasional fleeting reprieve, but all that does is allow you a few seconds to soothe your senses before the next onslaught of blastbeats, thrash riffs and balls-to-the-wall vocals. The album proceeds at a rapid gallop the whole way through, with only the closing track *Contemptuous* briefly knocking the BPM down a few notches (and taking quite a few cues from influential post-punk group Swans). Napalm Death have gone through more line-up changes than you can count on both hands and a few toes, but you wouldn't know it from the consistency on show here. Best listened to in its entirety, *Utopia Banished* is one of their most enjoyable releases from a long, distinguished career.

And then some:

Napalm Death are featured in the *Guiness Book of World Records*, as the writers of the shortest song: *You Suffer* from their debut album *Scum* (1987).

• The band was formed in 1981 and went through various name changes from Civil Defence to The Mess, Evasion and Undead Hatred.

• Napalm Death played their first concert at Atherstone Miners Club in Warwickshire on July 25. The bill also included Bible of Sins, Corrupt Youth, Hiroshima and Society's Victims.

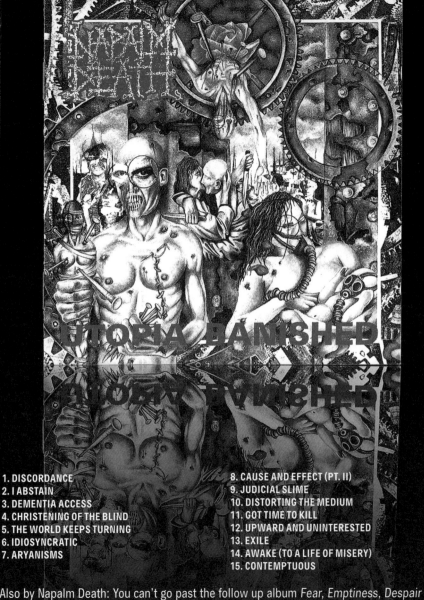

NAPALM DEATH

UTOPIA BANISHED

Also by Napalm Death: You can't go past the follow up album *Fear, Emptiness, Despair* (1994) which manages to combine all their previous influences onto one stellar record.

NEUROSIS
THE EYE OF EVERY STORM
2004

You listened to *Through Silver in Blood* and you thought, now that's heavy. You gave *A Sun that Never Sets* a spin and you thought, damn Neurosis, your brutality reigns supreme. Naturally, when *The Eye of Every Storm* dropped in 2004 you went out and bought shiny new speakers in anticipation of yet more aural carnage. And then...Moog synthesisers? Pianos? Bells? Did Neurosis spend the three years between releases in a health spa? Possibly. Was it worth it? Indubitably. Neurosis' eighth release is heavy without being aggressive, and metal without causing puncture wounds.

Scot Kelly's evocative vocals are somewhere in between that of Nick Cave and Glenn Danzig's: dark, haunting and poignant. Deep full base sounds pulsate throughout the entire album infusing the sadness and gloom with unmistakable groove. Steve Albini's exquisite fingerprints are all over this album. His ability to orchestrate vast pendulum swings between distorted sludgy guitars and quiet ambient passages is evidence of his impressive 20-year engineering career. Neurosis are obviously talented, disciplined musicians with the ability to execute intricate Opeth style songs, but the Bay Area quintet show remarkable restraint on this album. They've stripped back their sound to its raw, naked form and produced something creative, memorable and unbelievably satisfying.

BURN
NO RIVER TO TAKE ME HOME
THE EYE OF EVERY STORM
LEFT TO WANDER
SHELTER
A SEASON IN THE SKY
BRIDGES
I CAN SEE YOU

And then some:
• Before forming Neurosis, Scott Kelly and Dave Edwardson were members of Violent Coercion.
• When Steve von Till isn't playing/singing in Neurosis, he works as an elementary school teacher.
• Keyboardist Noah Landis is a founding member of 80s political punk band Christ on Parade.

1. BURN
2. NO RIVER TO TAKE ME HOME
3. THE EYE OF EVERY STORM
4. LEFT TO WANDER
5. SHELTER
6. A SEASON IN THE SKY
7. BRIDGES

Also by Neurosis:
Souls at Zero (1992), *Through Silver in Blood*
(1996), *Times of Grace* (1999) and *A Sun
that Never Sets* (2001) are all worthy of your
time and money.

NIGHTWISH
ONCE
2004

If Enid Blyton and J. R. R. Tolkein dropped a lot of acid and went on a *Fear and Loathing* style road trip, they may just come up with themes akin to those on Nightwish's fifth studio album *Once*. Steeped in fantasy, fairytales and unsettling dreams, *Once* (...upon a time? ...upon a midnight dreary? –The concept is deliciously vague) finds its home in the obscure category of symphonic power metal. Let's extrapolate. The "symphonic" derivation is fairly obvious: grandiose sweeping musical compositions and operatic vocals. The "power" element is evident in Nightwish's epic song structures and mythical/ fantasy based lyrical themes. The "metal" component is slightly less conspicuous. Jukka Nevalainen's drums are heavy, even speedy at times. Marco Hietala's vocals are dark and impassioned. Tuomas Holopainen's keyboards are dramatic and sinister when they need to be. So where's the ambiguity? It's the strangest thing...Nightwish have managed to produce metal without the slightest hint of aggression.

You won't find a pit at a Nightwish concert, or indeed a Lamb of God-style wall of death. You will however, find jam-packed arenas filled with devoted fans (some eerily so, with mirror-image Tarja get-up at pre-Olzon era shows). Since their debut in 1997, the Finnish quintet have sold millions of albums worldwide and garnered an enormous following. They've proven themselves to be masterful musicians, particularly with 2004's *Once*. Performing alongside the London Session Orchestra (who lent their talents to the *Lord of the Rings* trilogy), this album reaches heady heights of grandeur and musical creativity. Tuomas Holopainen outdid himself on this album; his songwriting is so inspired as to almost outshine Tarja Turunen's ethereal vocals. The band's musicianship is tight and worthy of the adoration gushing from fans across the globe. Once broadens the scope of heavy metal and as such, demands to be heard.

1. Dark Chest Of Wonders
2. Wish I Had An Angel
3. Nemo
4. Planet Hell
5. Creek Mary's Blood
6. The Siren
7. Dead Gardens
8. Romanticide
9. Ghost Love Score
10. Kuolema Tekee Taiteilijan
11. Higher Than Hope

And then some:
• Tarja Turunen was a guest judge on (Finnish) Idols.
• Tuomas Holopainen was born in Kitee, Finland on Christmas Day, 1976.
• Emppu Vourinen began playing guitar at age 12.

Also by Nightwish:
Oceanborn (1998) and *Wishmaster* (2000) are must-haves for Nightwish fans and for those who have embraced the post-Tarja era, *Dark Passion Play* (2007) shows a gallant vocal performance by Anette Olzon.

OPETH
BLACKWATER PARK
2001

Opeth's fifth studio album *Blackwater Park* – much like Pink Floyd's *The Wall* or Led Zeppelin's *Physical Graffiti* – is one that requires almost as much investment of time and energy on the part of the listener, as was required to conceive and record it. From the technically brilliant *The Leper Affinity* to the menacing and disturbing *Bleak* and the fluid and soaring *The Drapery Falls*, each movement on this album is an aural challenge requiring one's complete and unwavering attention to appreciate fully.

The range of non-metal influences on this album – progressive rock (*Harvest*), jazz, folk, and Latin – combined with flawless musicianship and colossal heaviness make for a landmark album in the expansive prog-death genre. Far from the "scary dudes screaming about Satan" impression proselytised by death metal's disparagers, Opeth have put forward something exquisite with this release –an intelligent counterargument that shoots such suppositions down in flames.

THE LEPER AFFINITY
BLEAK
HARVEST
THE DRAPERY FALLS
DIRGE FOR NOVEMBER
THE FUNERAL PORTRAIT
PATTERNS IN THE IVY
BLACKWATER PARK

And then some:
- The dual CD edition of *Blackwater Park* contains two extra tracks: *Still Day Beneath the Sun* and *Patterns in the Ivy II*, as well as the music video for *Harvest*.
- Opeth won a Swedish Grammy in 2003 for their album *Deliverance*.
- In 2004 Mikael Åkerfeldt & Peter Lindgren were ranked number 42 in *Guitar World*'s Top 100 Best Heavy Metal Guitarists of all Time.
- The album title *Blackwater Park* was inspired by the 1970s German progressive rock band of the same name.

Opeth

Blackwater Park

THE LEPER AFFINITY
BLEAK
HARVEST
THE DRAPERY FALLS
DIRGE FOR NOVEMBER
THE FUNERAL PORTRAIT
PATTERNS IN THE IVY
BLACKWATER PARK

Also by Opeth:
My Arms, Your Hearse (1998) and *Still Life* (1999) are nice and heavy or, if you're in the mood to relax with a jazz cigarette, try 2003's *Damnation*.

OZZY OSBOURNE
BLIZZARD OF OZZ
1980

You've headed one of the most famous bands in the world. You've been credited with inventing heavy metal. Your debilitating drug and alcohol addiction has you by the throat causing an almost perpetual state of apathetic inactivity. You are fired from the band, not just any band: Black Sabbath. That's gotta hurt. What now? You're 31 years old and are no where near ready to retreat into the cold shadows of anonymity. Enter Sharon, the pushy ambitious love of your life/manager. She cleans you up, hires a band and introduces you to the world as a solo artist. Definite marriage material.

The band hired to facilitate Ozzy's reincarnation was handpicked from metal's finest. 22-year old Randy Rhodes of Quiet Riot was chosen by Ozzy himself after playing only a few perfunctory warm up riffs. His mind-boggling talent was blindingly obvious from the get-go. Lee Kerslake of Uriah Heep was hired for his renowned drumming abilities and Bob Daisley of Rainbow settled in on bass and backing vocals. Blizzard of Ozz dropped in 1980 and achieved multi-platinum status. Crazy Train and Mr Crowley became two of the most covered songs in metal history (the latter earning Ozzy the PR-savvy title of Satanist). One of the best things about this album is that the spaces in between the giant hits are filled with equally brilliant, classic anthems (Revelation [Mother Earth], I Don't Know and Goodbye to Romance to name a few). Randy's neoclassical fretwork and soaring solos on this album earned worldwide praise and awards for Best New Talent and Best Heavy Metal Guitarist by Guitar Player and Sounds magazines respectively. All in all, Blizzard of Ozz is an exceptional album and a true metal milestone.

And then some:
- Ozzy Osbourne was sued over the track Suicide Solution after it was claimed that subliminal messages recorded in the song caused the suicide of teenager John McCollom. Ozzy was later cleared of all charges and claimed the song was inspired by Bon Scott of AC/DC.
- Randy Rhoads was posthumously inducted into the Guitar Centre Rock Walk on March 18, 2004.
- Bob Daisley and Lee Kerslake's contributions to Blizzard of Ozz were erased and replaced on the remastered versions of the album after they sued Ozzy and Sharon Osbourne for royalties and songwriting credits.

Also by Ozzy Osbourne:
Fans of old-school metal should have *Diary of a Madman* (1981) and *No Rest for the Wicked* (1988) on high rotation.

OZZY OSBOURNE
BARK AT THE MOON
1983

On March 19, 1982 Ozzy Osbourne's close friend and band mate Randy Rhoads boarded a light aircraft in Leesburg Florida. The coked-up pilot and tour bus driver Andrew Aycock attempted to swoop the buss which housed Rhoads' sleeping band mates. Instead, the aircraft's wing clipped the buss and sent Rhoads, Aycock and the band's hairdresser/ seamstress into a tail-spin. The plane crashed into a nearby property and all three were killed instantly. Rhoads was just twenty-five years old when he died. Despite his young age, he was considered a consummate guitarist. When Ozzy Osbourne was asked to describe what he felt the first time he heard Randy Rhoads play, he said "God entered my life".

Seven days later, the grief-stricken Prince of Darkness was back at work. After trialling a number of guitarists, Ozzy recruited former Dio axe grinder Jake E. Lee. Though fans were still mourning the loss of Rhoads, it was clear from the first riff of Bark at the Moon that Lee could hold his own. His blisteringly fast riffing and comparatively modern style brought pace and exuberance to the table, and fans couldn't help but welcome him into the fold. The title track of the album became Ozzy's signature tune and spawned a video that featured the Prince himself in a then creepy, now hilarious werewolf costume. Waiting for Darkness would become yet another cult classic from the album featuring one of the most memorable vocal performances of Ozzy Osbourne's career –his anguish is palpable and the results are spectacular. Now You See It Now You Don't is a very catchy Black Sabbath-ish highlight with a solid rhythm section and driving guitars, a higher tempo rocker to compliment the obligatory Osbourne ballads. Bark at the Moon is compulsory purchase for metal fans.

And then some:
• The original British pressing of Bark at the Moon featured the track Spiders in the Night (re-titled as Spiders) but not Slow Down. The American version featured Slow Down but not Spiders.

• In his later career, Jake E. Lee has recorded tributes to Randy Rhoads, AC/DC, Rush, Van Halen and Metallica.
• Ozzy Osbourne appeared as guest vocalist on the Was (Was not) dance track Shake Your Head (Let's go to Bed). The track featured Madonna on backing vocals but was remixed with the vocal stylings of Kym Basinger.

OZZY OSBOURNE

BARK AT THE MOON

1. BARK AT THE MOON
2. YOU'RE NO DIFFERENT
3. NOW YOU SEE IT (NOW YOU DON'T)
4. ROCK & ROLL REBEL
5. CENTRE OF ETERNITY
6. SO TIRED
7. SLOW DOWN
8. WAITING FOR DARKNESS
9. SPIDERS

Also by Ozzy Osbourne:
No More Tears (1991) and *Ozzmosis* (1995)
are both classic Ozzy, classic metal.

PANTERA
VULGAR DISPLAY OF POWER
1992

Starting out as a glam metal band, Pantera had stripped all but the slightest trace of mascara away by the time their second album Vulgar Display of Power arrived. It debuted at #1 on the Billboard charts and Pantera established itself as one of the biggest names in 90s US metal. Pantera's musical approach on *Vulgar Display of Power* would resonate with many bands to come after them –theirs was a sound that proved sheer speed wasn't the only way to create truly brutal music. That's not to say this album doesn't have moments of high-speed shredding, it certainly does, but it was the "power groove" they applied that would set them apart.

Phil Anselmo's face-melting screams reveal slight remnants of his hair metal (teased) roots. Thankfully, his guttural work adds a convincing brutality and eliminates any lingering Van Halen comparisons. "Dimebag" Darrell's performance on this album would see him become one of the world's most popular (obviously not with everyone, he was murdered in 2004) and well-known metal guitarists over the next decade. Cuts that appeared on *Vulgar* remain some of the band's best known material: *Mouth For War*, *Walk* and *Fucking Hostile* have made numerous "best ever metal songs" lists around the world. As an album, *Vulgar Display of Power* still stands as one of the most brutal and genre-changing ever released. Best played in a bad mood.

And then some:

• 1993's *Vulgar Video* captured the band in all their metal superstar glory and features hard drinking, drugs, scantily clad women, and occasionally some music.

• The guy getting punched on the *Vulgar* album cover was paid $300 by label executives, or $10 a punch. It took 30 punches to get the right shot.

• Pantera composed the fight song for the Dallas Stars –a National Hockey League team based in Dallas Texas.

PANTERA

VULGAR
DISPLAY OF
POWER

Also by Pantera
Far Beyond Driven (1994) was the follow
up to *Vulgar* and remains one of the biggest
metal albums of all time.

PARADISE LOST
DRACONIAN TIMES
1995

This is not music to eat waffles by, unless those waffles are drenched in the tears of a lost love. These are not the tunes of sunny days or lemonade in tall glasses or balmy evenings at the beach. This is music to weep to, to wallow in the murky slough of your own self pity. Paradise Lost do misery and depression like no other and as such, pioneered the goth metal scene. Their patented pity parties have influenced the likes of Nightwish, Lacuna Coil and Swedish sad-clowns Katatonia to name a few.

Draconian Times marked a significant change in style for Paradise Lost as they waved a teary goodbye to their death metal roots and fully embraced the doomy gothic style that has come to define them. Nick Homes exchanged his death grunts for melancholic singing and even spoken passages. A devoted pupil of the James Hetfield School of Rock, Homes brings aggression and power to the morose cuts on *Draconian Times*. Track lengths are kept to a tight, radio-friendly 4-minute average, avoiding the doom-metal tendency to languish in self-indulgent noodling. Eerie pianos, chiming guitars, classical organs and Gregorian-style vocal work show a band willing to experiment. If you're a fan of goth metal, doom metal or Ann Rice-style subject matter, *Draconian Times* will have you blissfully wretched in no time.

And then some:
- In 2009, Paradise Lost recruited Adrian Erlandsson (At The Gates/Cradle of Filth) as their fulltime drummer.
- Since their debut in 1990, Paradise Lost have issued releases through Peaceville Records, Music for Nations, Jive Records, EMI, Electrola, Gun Records, Koch Records, Bertelsmann Music Group and Century Media Records.

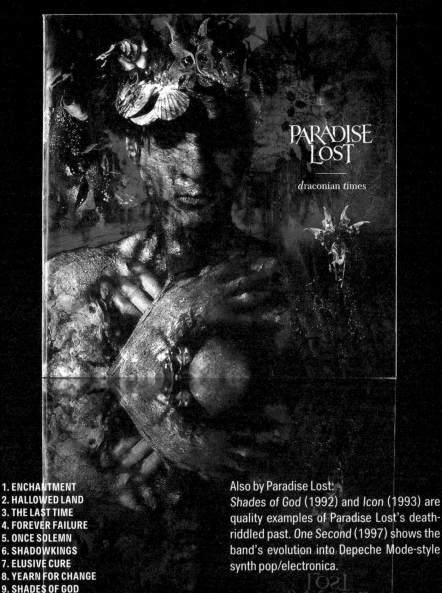

PARADISE
LOST

draconian times

Also by Paradise Lost:
Shades of God (1992) and *Icon* (1993) are quality examples of Paradise Lost's death-riddled past. *One Second* (1997) shows the band's evolution into Depeche Mode-style synth pop/electronica.

QUEENSRŸCHE
OPERATION: MINDCRIME
1988

The very...uh...concept of concept albums is decidedly un-metal: a story told from beginning to end with various characters, numerous actors, chanting, sound effects, spoken interludes between songs and recurring musical themes. It's a recipe for cheesiness and the success rate of such albums is fairly sketchy to say the least. But when they're done well (Mastodon's Leviathan is a shining example), a "concept" can elevate an album from a pleasant recording to an epic journey. Queensrÿche's *Operation: Mindcrime* was a great leap forward in the genre of concept albums, and is still hailed as one of the first progressive metal albums ever made. It set the scene for those to follow (Dream Theater, Symphony X, etc.) and raised the bar in terms of production standards.

Operation: Mindcrime tells the tale of Nikki –a heroin addict disillusioned with American society who joins a secret organisation of radical revolutionaries headed by the murderous demagogue Dr. X. Under the control of Dr. X (who manipulates Nikki through his heroin addiction and brainwashing) Nikki is turned into an assassin poised to kill whomever the good doctor wishes. That, obviously, is the short version. The album's exploration into the human mind, manipulation, cold brutality and insanity seems almost impossible on paper, but *Operation: Mindcrime* is performed by some of the best (if underrated) metal minds. Scott Rockenfield's drumming improves with each listen, Eddie Jackson's bass is subtle yet solid and Geoff Tate's operatic/Bruce Dickinson-esque vocals are just incredible. But it's the staggering chemistry between guitarists Chris DeGarmo and Michael Wilton that differentiates Queensrÿche from its many inferior imitators. This is a band playing at their peak, on a landmark metal album with one hell of a story.

And then some:
- After his departure from Queensrÿche, Chris DeGarmo became a professional charter pilot.
- *Operation: Mindcrime II* was released in 2006. Though musically ambitious, it doesn't pack the same punch as the original and is probably best avoided.

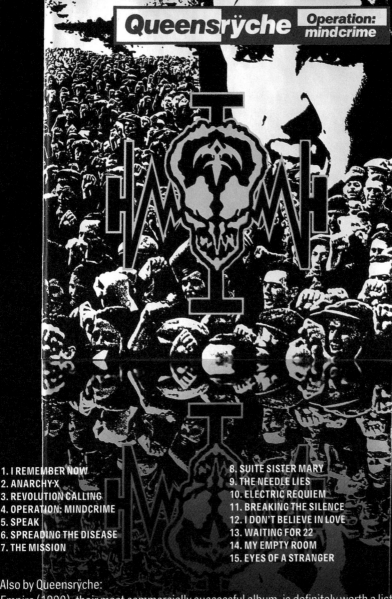

Queensrÿche — Operation: mindcrime

Also by Queensrÿche:
Empire (1990), their most commercially successful album, is definitely worth a listen.

RAGE AGAINST THE MACHINE
RAGE AGAINST THE MACHINE
1992

Thích Quáng Dúc burned himself alive in protest of the persecution of Buddhists, and you're wondering if you could've got this album cheaper on Ebay. Bobby Sands starved himself to death seeking to regain Special Category Status for political prisoners and you're busy cursing the banality of music "these days". Huey P. Newton founded the Black Panther Party for Self Defence and you...you put this record on and are instantaneously overcome with the violent urge to take a stand, lead a revolt or at least make a controversial sign out of cardboard, crayons and crazy glue. Raise your fist, not your horns: This is fight music.

Rage Against the Machine put rap and early 80s L.A. hardcore punk in a vicious metal blender and the results were stupefying. Their self-titled album is one of the most aggressive, formidable releases in metal history (yes, that includes death metal, black metal and I-wanna-eat-your-babies gore metal). It doesn't merely bring issues to light and "make you think", it stomps on your face with a giant boot of righteousness until you are just battered and angry enough to take to the streets for your own cause, whatever that may be. Zach de la Rocha's Bob-Marley-meets-Public-Enemy-in-a-prize-fight lyrical approach is a revolution in and of itself. Tom Morello's electrical violence will have you demanding to know why his genius was only recognised through Audioslave. The album's powerhouse drumming and beefy bass lines will murder your stereo thanks to Garth "GGGarth" Richardson's immaculate production. *Killing in the Name, Bullet in the Head, Bombtrack, Wake Up, Freedom*...nothing satisfies like sweet, sweet Rage.

And then some:

• Tool vocalist Maynard James Keenan and Jane's Addiction drummer Stephen Perkins both appear on the track *Know Your Enemy*.

• Though *Killing in the Name* is one of RATM's greatest ever singles, it features just six lines of lyrics.

• *Wake Up* is used in *The Matrix* soundtrack and *Calm Like a Bomb* (from *The Battle of Los Angeles*) featured in *The Matrix Reloaded* soundtrack.

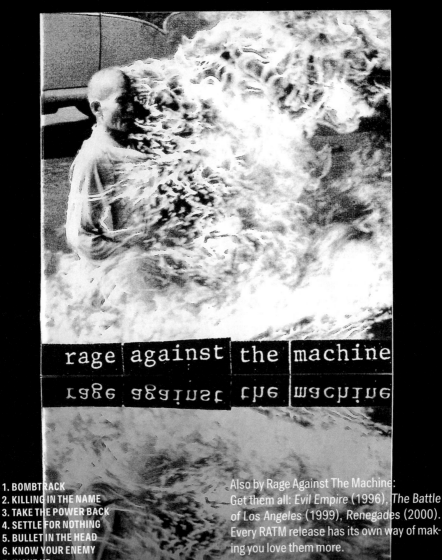

rage against the machine

Also by Rage Against The Machine:
Get them all: *Evil Empire* (1996), *The Battle of Los Angeles* (1999), *Renegades* (2000). Every RATM release has its own way of making you love them more.

RAINBOW
LONG LIVE ROCK 'N' ROLL
1978

Puppet master Ritchie Blackmore has always had his finger on the "the scene's" unpredictable pulse. After transforming Elf into Rainbow, Blackmore set about hiring and firing a plethora of talented musicians until he'd settled on the ultimate line-up of Elf's original lead singer Ronnie James Dio, Uriah Heep / Yngwie Malmsteen bassist Bob Daisley, underrated Symphonic Slam keyboardist David Stone and future Whitesnake / Black Sabbath drummer Cozy Powell. Though his ambitions were ruthless and seemingly void of compassion, Blackmore succeeded in creating one of the most formidable line-ups in Rainbow and indeed heavy metal history. Alas, like all good things, it wouldn't last. Blackmore's chess-like strategies would out-manoeuvre pretty much everyone until all that was left of Rainbow was a complex catalogue and one shining product of the glory days: *Long Live Rock 'n' Roll*.

Each world-class musician gives a flawless performance on this album. The classically trained Blackmore is at his finest, executing exotic scales in the monstrous *Gates of Babylon* and a spectacular slide guitar solo in *Lady of the Lake*. *Kill the King* is an all out stomper with inklings of speed metal definitely present. Dio's voice is positively menacing when it needs to be (*The Shred*) and romantic where appropriate (*Rainbow Eyes*). Rainbow's third album has often been described as bridging the gap between metal and rock 'n' roll. Certainly, the sheer variety offered on *Long Live Rock 'n' Roll* incorporates catchy blues rock, elements of funk and of course, the heavy driving force of pre 80s metal. There are no bad tracks, there's nothing to dislike, you have no excuses.

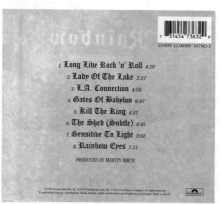

1. Long Live Rock 'n' Roll *4:20*
2. Lady Of The Lake *3:37*
3. L.A. Connection *4:58*
4. Gates Of Babylon *6:47*
5. Kill The King *4:27*
6. The Shed (Subtle) *4:45*
7. Sensitive To Light *3:02*
8. Rainbow Eyes *7:31*

PRODUCED BY MARTIN BIRCH

And then some:
• Yngwie Malmsteen performed a cover of Gates of Babylon on his 1988 album *Inspiration*.
• Ronnie James Dio left Rainbow after this album to join Black Sabbath and was replaced by Graham Bonnet.
• The name Rainbow was inspired by the name of a Hollywood bar and grill.

Rainbow

Long Live Rock 'n' Roll

1. LONG LIVE ROCK 'N' ROLL
2. LADY OF THE LAKE
3. L.A. CONNECTION
4. GATES OF BABYLON
5. KILL THE KING
6. THE SHED (SUBTLE)
7. SENSITIVE TO LIGHT
8. RAINBOW EYES

Also by Rainbow:
The excellent Rising (1976) features a slightly different line-up though the killer trio of Dio, Blackmore and Powell remains

RAMMSTEIN
MUTTER
2001

Rammstein play a special kind of metal. They're considered Neue Deutsche Härte, but incorporate everything from industrial metal to punk rock, electronica and even pop. Whether or not such an obscure hybrid sound can even be classified as metal has never actually been up for debate when it comes to Rammstein. Funny that. It could be because the Germen sextet seems about as approachable as a test tube of flesh-eating viral cultures or, (more likely) because whatever they're doing, it's working.

Mutter begins with *Mein Herz Brent*, a slow beautiful opener with soft, quiet vocals and piano samples. There's something distinctly unsettling about Rammstein performing a lullaby. Till Lindeman's gentle crooning feels akin to having Charles Manson bake you a cake: the sentiment is there but you can't shake that feeling of...I don't know...imminent death? This atmospheric discomfort envelops the entire album as Rammstein manage to simultaneously yank at your heartstrings and claw out your innards. The lyrics can be funny (as in *Zwitter* which tells the story of a hermaphrodite with a predilection for digital stimulation) or intensely creepy: *Now dear children, pay attention / I am the voice from the pillow / I have brought you something / I ripped it from my chest.* Between pungent guitars, industrial beats and Wagnerian string samples, Rammstein have created a dazzling 45-minute ode to wretched self-loathing.

And then some:

• The name Rammstein is taken from the West German town of Ramstein-Miesenbuch, the site of the Ramstien flight show disaster of 1988 in which 67 spectators and 3 pilots died. The extra "m" in the band's spelling creates a direct translation to "ramming stone".

• Rammstein have not experienced any line-up changes since their inception in 1994.

RAMMSTEIN
MUTTER

1. MEIN HERZ BRENNT
2. LINKS 2 3 4
3. SONNE
4. ICH WILL
5. FEUER FREI!
6. MUTTER
7. SPIELUHR [FEAT. KHIRA LI LINDEMANN]
8. ZWITTER
9. REIN RAUS
10. ADIOS
11. NEBEL [FEAT. CHRISTIANE "BOBO" HERBOLD]

Also by Rammstein:
Sehnsuct (1997) and *Reise, Reise* (2004)
are essential records for any fan of industrial
metal.

SAXON
STRONG ARM OF THE LAW
1980

If you're not familiar with the NWOBHM initialism, here's a quick rundown: the New Wave of British Heavy Metal era emerged in the late 70s when Led Zeppelin and Deep Purple's psychedelic stars were fading. Bands such as Motörhead, Iron Maiden, Diamond Head and Saxon pioneered the scene with their heavy almost punkish sound incorporating faster tempos and less of the bluesy elements favoured by Black Sabbath. *Strong Arm of the Law* is one of the best examples of NWOBHM ever produced. Well ahead of its time, this album influenced innumerable bands across a wide range of heavy metal subgenres and continues to inform the scene today.

Consistency is what makes this album Saxon's strongest. It's packed throughout with confident fist-thrusting anthems and hook-heavy scream-alongs like *Sixth Form Girls. Heavy Metal Thunder, To Hell and Back Again* and *20 000 ft* are pure speed metal classics. The pace is slackened somewhat on *Dallas 1pm* and the title track, but these songs are heavy and gritty enough in their own right. Saxon perfected their distinctive sound on this album with more defined riffs and tighter song structures than on previous releases. This is raw, edgy metal executed with Judas Priest-style aggression and Thin Lizzy swagger. If you require schooling in the NWOBHM movement, *Strong Arm of the Law* is the ultimate primer.

Original Album 1980
1. Heavy Metal Thunder
2. To Hell And Back Again
3. Strong Arm Of The Law
4. Taking Your Chances
5. 20,000 Ft
6. Hungry Years
7. Sixth Form Girls
8. Dallas 1 PM

Bonus Tracks:
Studio B15, BBC Session 25th April 1982
9. 20,000 Ft
10. Dallas 1 PM
11. The Eagle Has Landed
12. 747 (Strangers In The Night)

13. To Hell And Back Again *(Alternate Version)*
14. 20,000 Ft *(Abbey Road mix 2009)*
15. Mandy *(Early version of Sixth Form Girls)*
16. Heavy Metal Thunder *(Abbey Road mix 2009)*

Original album produced by Saxon & Pete Hinton

The Official Saxon Website: www.saxon747.com

Released in October 1980, Saxon's third album (and second LP of 1980) was the second to be produced by the band in association with Pete Hinton at Rampart Studios. Opening with the self-explanatory 'Heavy Metal Thunder', like its predecessor Wheels Of Steel, Strong Arm Of The Law features many tracks that have remained staples of Saxon's live set to the present day, and now includes the complete 1982 Kid Jensen B15 session, recorded live in the studio for BBC Radio 1, new mixes taken from the original 24 track tapes of '20,000 Ft' and 'Heavy Metal Thunder', plus an alternate take of 'To Hell and Back Again', remixed at Abbey Road Studios by Pete Mew. It also features the previously unreleased 'Mandy', an early working version of 'Sixth Form Girls'. It also features rare memorabilia and extensive liner notes written in co-operation with lead singer Biff Byford.

And then some:
• Saxon were originally called Son of a Bitch –a name Graham Oliver and Steve Dawson would resuscitate in 1994.
• Saxon appeared on *Harvey Goldsmith's Get Your Act Together* –a show in which Goldsmith attempted to restore the band to their previous heights of popularity.
• Frontman Peter "Biff" Byford has released an autobiography entitled *Never Surrender*.

Also by Saxon:
Wheels of Steel (1980) released just six months before Strong Arm of the Law is a first-rate release, as is Denim and Leather (1981).

ΛEPULTURΛ
CHAOS A.D.
1993

The phrase "Brazilian heavy metal" for most people conjures up but one name: Sepultura. This talented 4-piece fused seditious political lyrics with some of the best metal of the 80s and 90s, proving the genre to be more malleable than ever thought possible. Without disrespecting their thrash metal roots, Sepultura slowed their pace on this album, bringing it down from breakneck to wickedly catchy (note: still brutal). Further experimentation saw the band incorporate more industrial overtones and robust Brazilian percussion styles. This album along with others like Pantera's *Vulgar Display of Power* would form the bedrock of the style known as groove metal.

Refuse/Resist, Territory and *Propaganda* – the singles from the album – show an inspired diversity in sound and speed ranging from all-out shredding to chunky, sludgy riffing. Normally, quieter acoustic offerings from metal acts can lose said act a lot of credibility – not so with *Kaiowas*. This stunning, heavily percussive track would become one of the staples of Sepultura's renowned live show. Recorded live for the album among the ruins of the medieval castle of Chepstow, this cut is as intriguing and guileless as the band itself. It has been said that Sepultura write protest songs, but *Chaos A.D.* offers something more along the lines of a post-apocalyptic riot.

And then some:

• Sepultura side projects and offshoots are also highly regarded – Nailbomb, a collaboration between Max Cavallera and Alex Newport of Fudge Tunnel released the incredible Point Blank in 1994. The post-Sepultura group Soulfly have released six albums with more on the way.

• Drummer Igor Cavallera along with his wife Laima has more recently made a name for himself as an electro DJ under the name Mixhell.

SEPULTURA

CHAOS A.D.

1. REFUSE/RESIST
2. TERRITORY
3. SLAVE NEW WORLD
4. AMEN
5. KAIOWAS
6. PROPAGANDA
7. BIOTECH IS GODZILLA
8. NOMAD
9. WE WHO ARE NOT AS OTHERS

Also by Sepultura:
Check out *Arise* (1991) and *Roots* (1996) to
see why Sepultura will never lose their foot-
hold among the heavy metal elite.

SKID ROW
SKID ROW
1989

You may have bought this album for the singles, but you kept it because played in its entirety, nothing rocks like *Skid Row*. Their hair was big, their lyrics inane and Sebastian Bach may have been the prettiest boy in metal, but Skid Row were undeniably heavy for their time. Though White Lion, Mötley Crüe, Ratt and Journey had already arrived on the scene in clouds of hairspray by 1989, Skid Row's infection riffs and catchy beats spread like a disease and their debut release went five times platinum.

Squealing guitars and crashing drums distinguished Skid Row from the likes of Warrant and Poison and garnered a fan base more attuned to Guns N´Roses than Bon Jovi. *18 and Life, I Remember You* and the raucous anthem *Youth Gone Wild* connected with fans in a way the likes of King Kobra never could. By today's lofty standards, the production on Skid Row is somewhat lacking, but the musicianship is first-rate and the songwriting timeless. You will scream along with Bach, you'll air-drum till your biceps burn, you owe it to yourself to get this album.

And then some:

• After Skid Row, Sebastian Bach set his sights on Broadway, performing in the musicals *Jesus Christ Superstar* and *Jekyll and Hyde*.

• In 2007, Skid Row recorded *Jingle Bells* for a Monster Ballads Christmas album.

• Sebastian Bach's father painted the cover art for the band's second album *Slave to the Grind*.

Also by Skid Row:
Skid Row's sophomore release *Slave to the Grind* (1991) picks up right where their debut left off.

SLAYER
REIGN IN BLOOD
1986

Slayer's seminal slice of pseudo-Satanist thrash ranks as a landmark in the rock continuum, signalling the beginning –and possibly even the pinnacle– of a new kind of heavy: coruscating, concussive and thrillingly relentless. The album's antecedents may be in the hardcore punk that was de rigueur in the mid 80s LA scene (Slayer's stomping ground) but it also anticipates something faster, louder and badder, practically inventing death metal in the process.

As neat as it is shattering, *Reign in Blood* clocks in at only 29 minutes and bears witness to the band's deceptively deft musicianship (something that's easy for a listener to overlook when they're in the midst of this kind of aural pounding). Yes, Slayer deliver a veritable blitzkrieg of sonic aggression, perpetually frenetic and quite literally dizzying, but there's a method to the madness and a perfectly poised ferocity made possible by technique and skill. Some kudos should go to producer Rick Rubin for this; his clean production brings each musician's talent to the fore, making redundant those lazy accusations that this kind of brutality is "mere noise": there is a definite groove lurking inside the maelstrom and if you can't discern it, you should probably stick to Bon Jovi. *Reign In Blood* designed the thrash metal template and then set fire to it. Its genius is undisputed and its merits plentiful, chief of which is the fact that the heaviness remains entirely undiminished nearly 25 years after its initial release.

And then some:
- *Reign in Blood* is Slayer's first collaboration with Rick Rubin.
- A looped section of the guitar riff from *Angel of Death* appears in the song *She Watch Channel Zero?!* by Public Enemy.
- Tori Amos covered *Raining Blood* on her 2001 album *Strange Little Girls*.

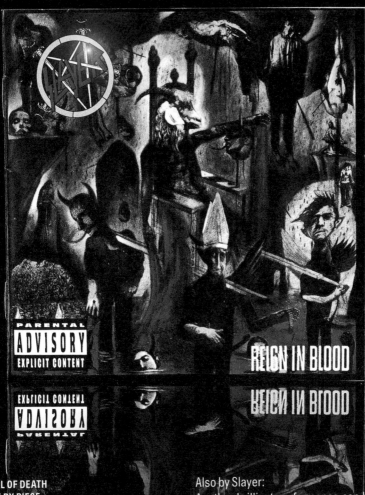

REIGN IN BLOOD

Also by Slayer:
Another brilliant performance can be heard on the live album *Decade of Aggression* (1991).

SLAYER
SEASONS IN THE ABYSS
1990

If there was a heavy metal brutality pageant, Slayer would win. By win I mean they would beat their competition to a lifeless pulp, and brandish their blood-spattered, petroleum jelly-smeared sash with pride. Since forming in 1981, Slayer have managed to out-metal just about everyone in their unruly peer group. Their music is stronger, their themes are darker and their talent is more obvious. *Seasons in the Abyss* is largely considered Slayer's definitive album, fusing the speed of *Reign in Blood* with the iniquity of *South of Heaven*. It's more accessible and digestible than Slayer's previous releases, yet retains the grievous-bodily-harm flavour intrinsic to their entire catalogue.

Let's begin with the lyrical content –an inevitable source of entertainment on any Slayer album. Satan and his teen-angst sensibilities a-la Hell Awaits have been usurped with the horrors of war, oppressive communist regimes and of course the inner workings of a serial killer. Not just any serial killer though, this is Slayer after all. *Dead Skin Mask* concerns the nauseating habits of one Ed Gein. Gein enjoyed (among myriad of other stomach-churning behaviours) exhuming the bodies of recently buried women, tanning their skin and producing various masks, crafts and the infamous "woman suit"—ideal Slayer material (in terms of inspiration rather than schadenfreude). *Seasons* is the last album to feature the drumming virtuosity of Dave Lombardo and he makes every last lashing count. Tom Araya's vocals span the breadth of metallic possibilities, ranging from ghostly to beastly as needed. The guitars burn through every cut, screaming and shredding with deadly precision whilst allowing slivers of melody to shine through. If you're not into Slayer, you're not into metal.

And then some:
- Jeff Hanneman and Kerry King formed Slayer in 1981 after meeting at an audition for another band.
- Rick Rubin paid guitarist Kerry King 100 dollars to lay down a guitar solo for the Beastie Boys track *No Sleep till Brooklyn*.
- Slayer began their career playing covers of Iron Maiden and Judas Priest songs at clubs and parties in Southern California.

1. WAR ENSEMBLE
2. BLOOD RED
3. SPIRIT IN BLACK
4. EXPENDABLE YOUTH
5. DEAD SKIN MASK
6. HALLOWED POINT
7. SKELETONS OF SOCIETY
8. TEMPTATION
9. BORN OF FIRE
10. SEASONS IN THE ABYSS

Produced by Rick Rubin
Co-Produced by Andy Wallace and Slayer

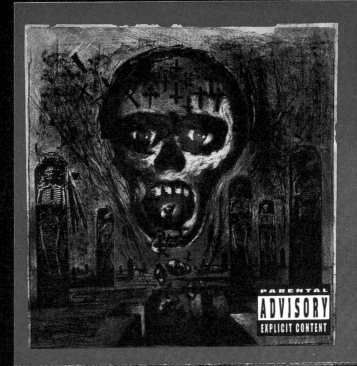

1. WAR ENSEMBLE
2. BLOOD RED
3. SPIRIT IN BLACK
4. EXPENDABLE YOUTH
5. DEAD SKIN MASK
6. HALLOWED POINT
7. SKELETONS OF SOCIETY
8. TEMPTATION
9. BORN OF FIRE
10. SEASONS IN THE ABYSS

Also by Slayer:
South of Heaven (1988) is a classic Slayer album –heavy, dark and sinister.

ΛLAYER
ᴳOD ʰATES US ΛLL
2001

When Reign in Blood dropped in 1986, the opening track Angel of Death saw Slayer accused of racism and labelled Nazi sympathisers. They're video for Seasons in the Abyss was filmed in Egypt and inadvertently released around the same time the Gulf War broke out. Naturally, Slayer's eighth studio album was delayed in production due to various mishaps and came out on September 11, 2001 baring the untimely, controversial title God Hates Us All. Though disapproving media storms seem to eddy around majority of Slayer's releases, it's nigh on impossible to find (musical) fault with God Hates Us All – one of the best albums of their long successful career.

This is Slayer at their most vicious. Gone are the comparatively upbeat nu-metal elements of 1998's Diabolus in Musica, as the L.A thrashers return to the beloved flesh-ripping brutality of yore. With guitarist Kerry King penning most of the tracks, the lyrics were bound to be brutal. King went for the more relatable themes of revenge, religion and self-control as opposed to "Satan this, Satan that [and] the usual Dungeons and Dragons shit" of previous records. Tom Araya's tortured, searing screams could give credibility to even the most pedestrian of lyrics and indeed, saying "fuck" 16 times in 3 in minutes on Payback seems absolutely necessary. Shrieking atonal solos, inconceivable riffage, interminably punishing drums—Slayer flips metal "trends" the bird and gives fans what they deserve: an almighty arse-kicking.

And then some:
• God Hates Us All was recorded in Brian Adams' studio in Vancouver Canada. To make the band feel more at home, the studio was decorated with candles, skulls, pornography and a crime-scene style chalk outline of a body on the floor.
• Drummer Paul Bostaph reluctantly left the band soon after this album was released due to a chronic elbow injury. He likened the experience to "breaking up with a girlfriend".
• Tom Araya read books about serial killers in his spare time to make his vocals on the album more convincing.

1. DARKNESS OF CHRIST
2. DISCIPLE
3. GOD SEND DEATH
4. NEW FAITH
5. CAST DOWN
6. THRESHOLD

7. EXILE
8. SEVEN FACES
9. BLOODLINE
10. DEVIANCE
11. WAR ZONE
12. HERE COMES THE PAIN
13. PAYBACK

Also by Slayer:
All Slayer fans should own *Show No Mercy* (1983) and *Hell Awaits* (1985).

ΛLIPKNOT

IOWA
2001

There are two types of people in this world: those who love Slipknot, and those who hate them with equal passion. Indifference is a feeling rarely associated with the Iowan nonet. Whilst some cynical metal purists may consider Slipknot nothing more than shrewd businessmen exploiting teenage angst for their own financial gain, the reality is more likely rooted in the fact that their music reflects their own angst. Angst caused by a mind-numbing suburban existence, minimum wage jobs, absent parents, TV preachers, and shopping malls.

Iowa is a massive musical flip off to all of that. The album opens with *(515)* – the telephone area code of central Iowa – a mess of distortion and tortured screams, before launching into *People = Shit*, a furious, stomping, neck-cracking anthem that would have the neocons running for the hills if this was played at the Republican National Convention. The anthemic motif continues with tracks such as *My Plague, The Heretic Anthem* and *Left Behind* creating a cathartic soundtrack for the Weltschmerz-ridden lives of the young and young at heart. Iowa strikes a neat balance between technicality and catchiness (no doubt a result of Joey Jordison's desire to "create a song that sticks in people's memories") which results in an MTV-friendly air drummer's wet dream.

And then some:
- The Japanese edition of *Iowa* includes a live version of *Liberate*.
- *Iowa* reached #1 on the UK Albums Chart, #2 on the ARIA Charts, and #3 on the Billboard 200.
- In 2002 drummer Joey Jordison appeared on guitar with his side project, The Murderdolls, in an episode of *Dawson's Creek*.

1. (515)
2. PEOPLE = SHIT
3. DISASTERPIECE
4. MY PLAGUE
5. EVERYTHING ENDS
6. THE HERETIC ANTHEM
7. GENTLY

8. LEFT BEHIND
9. THE SHAPE
10. I AM HATED
11. SKIN TICKET
12. NEW ABORTION
13. METABOLIC
14. IOWA

Also by Slipknot:
1999's eponymous debut, and 2004's *Vol. 3: (The Subliminal Verses)* are delightful celebrations of unabashed hatred.

SYSTEM OF A DOWN
TOXICITY
2001

"All research and successful drug policy show/ That treatment should be increased / And law enforcement decreased / While abolishing mandatory minimum sentences". Take that to the bank, metal detractors. You thought metal could only come in the form of an angry wall of noise buoyed by impotent, infantile lyrics? Well, you were...oh ok, you're looking at track seven *"Jump Pogo?... Bounce Pogo, Down Pogo, Up Pogo"* –fair point. But the fact still remains, every word that comes out of Serj Tankian's mouth can be loosely classified as either a threat, a command, or a declaration of war.

After listening to SOAD's sophomore release, you can't help feeling a little browbeaten. They may be drawing your attention to the abhorrent state of the penal system or the human propensity to judge an entire life based on the final battle...whatever the issue, it's shoved in your face. And it's awesome. It's not just the lyrics that drive every point home like a hand grenade in your conscience. Guitarist Daron Malakian adds a frenzied, panicky element to each cut with some bizarre screeching effects and also manages to pull off one of the most beautiful intros of System's career (*ATWA*, check it out). John Dolmayan's eclectic rhythms work in perfect synergy with Shavo Odadjian's Eastern bass lines and as usual, wherever there is exceptional music, Rick Rubin can be found lurking in the shadows. *Toxicity* has all the power and intensity of a head-on collision. Get it before it gets you.

COL 501534 2

5 099750 153420

1. PRISON SONG
2. NEEDLES
3. DEER DANCE
4. JET PILOT
5. X
6. CHOP SUEY!
7. BOUNCE
8. FOREST
9. ATWA
10. SCIENCE
11. SHIMMY
12. TOXICITY
13. PSYCHO
14. AERIALS

COLUMBIA

And then some:
• Serj Tankian formed the Axis of Justice with legendary guitarist Tom Morello –a non-profit organisation dedicated to bringing musicians, fans and political organisations together in a fight for "social justice".
• SOAD has been in "permanent" hiatus since 2006, with each of its four members currently working on side projects.

1. PRISON SONG
2. NEEDLES
3. DEER DANCE
4. JET PILOT
5. X
6. CHOP SUEY!
7. BOUNCE

8. FOREST
9. ATWA
10. SCIENCE
11. SHIMMY
12. TOXICITY
13. PSYCHO
14. AERIALS

Also by System of a Down:
System of a Down (1998) and *Mesmerise/Hypnotise* (2004/05) are truly brilliant releases

TESTAMENT
THE LEGACY
1987

Though a quick flip through radio frequencies may occasionally leave you in dismay, the scope of music in general and heavy metal in particular is infinite. There will always be harder, faster, heavier, nastier music than what is considered unsurpassable today. When Testament shoved *The Legacy* in our faces in 1987, there was already a plethora of heavy hitters in Bay Area thrash scene. Exodus' *Bonded by Blood* and Metallica's *Kill 'Em All* defined the early 80s sound and had championed the burgeoning genre. But the mid 80s brought a new wave from the Bay; Death Angel, Heathen, Forbidden and Testament brought complexity and NWOBHM sensibilities to thrash and revolutionised the scene once again.

The guitars on this album are nothing short of heroic. Skolnick and Peterson execute some of the most salient solos in thrash (*Over the Wall*) and unbelievable mid paced, half time riffs (*The First Strike is Deadly*). Chuck Billy's vocals would never again reach this level of power and aggression as he morphed into something of a James Hetfield impersonator on subsequent Testament albums. The rhythm section is strong and compact and Clemente drums as if his life depends on it. This is the album that earned Testament their cult following. If you're a relatively new fan of pure fist-clenching metal and haven't heard this disk, you owe it to yourself to check it out. *The Legacy* is just that –an album that left it's mark on metal as the perfect thrash debut.

And then some:

• Testament was formed by Eric Peterson and his cousin Derrick Ramirez under the name The Legacy.

• Testament's many line-up changes have included Dave Lombardo (Slayer), Gene Hoglan (Dark Angel, Dethklok), Chris Kontos (Machine Head) and Steve DiGiorgio (Iced Earth).

• Guitarist Eric Peterson formed a symphonic black metal side project with Steve DiGiorgio (latter day Testament) and Steve Smyth (Nevermore) called Dragonlord.

Also by Testament:
Practice What You Preach (1989) is another solid Testament release featuring less Satanic lyrics in favour of more socio-political themes.

TOOL
ÆNIMA
1996

Listening to a Tool album is like being simultaneously smacked in the face and passionately kissed. After the initial blow subsides, sonorous bass lines and melodic vocals lull you into a false sense of security as the intensity builds, until finally what thunders in is nothing short of a musical hurricane. *Ænima* epitomises the Tool sound: musically innovative, lyrically engaging, and defiant to the very core. Drawing influence from rebellious comedian Bill Hicks, and including extended samples of his work in the track *Third Eye*, the album decries the materialism of Hollywood, mainstream pop culture and organised religion (most notably Scientology). *Ænima* embraces lyrical irony and black humour while smashing out some of the most memorable riffs of the decade.

To label Tool's style as progressive metal is to underestimate their impact on metal in the late 1990s and early 2000s. If Tool's first full-length album *Undertow* was an anachronism in a grunge-dominated alternative scene, then *Ænima* was ahead of its time in musical experimentation and complexity. Eventually going triple-platinum, and winning a Grammy for Best Metal Performance in 1998, this album is, in a word, perfect. Every beat moves you, every lyric makes you think, Maynard's voice is like some kind of heavy metal chocolate...almost too good. You can't not love this record.

And then some:
• To the surprise of many, vocalist Maynard James Keenan appeared on stage with Tori Amos in 1997, accompanying Amos in a performance of her song *Muhammed My Friend*.
• *Die Eier Von Satan*, while employing an industrial, militaristic sound, is actually a recipe for hash cookies read aloud in German.
• In 1993, Tool spent the better part of a Hollywood gig baa-ing at the audience like sheep because they discovered the venue was owned by the Church of Scientology.

1. STINKFIST
2. EULOGY
3. H.
4. USEFUL IDIOT
5. FORTY SIX & 2
6. MESSAGE TO HARRY MANBACK
7. HOOKER WITH A PENIS

8. INTERMISSION
9. JIMMY
10. DIE EIER VON SATAN
11. PUSHIT
12. CESARO SUMMABILITY
13. ÆNEMA
14. (-) IONS
15. THIRD EYE

Also by Tool:
Begin your musical awakening with *Undertow* (1993) and modify your mind with the
mathematically intricate *Lateralus* (2001).

TROUBLE
MANIC FRUSTRATION
1992

After years if toiling in the viscous swamps of musical obscurity, Trouble were manically frustrated. Their irrefutable talent seemed to only take them so far, and internal turbulence resulted in line-up changes and the tart smack of arrested development in the mouths of Trouble's founding members. But then came Rick Rubin, the bearded redeemer, who turned the band's frowns into grungy metal grimaces. *Manic Frustration* marked a significant change in style for Trouble whose previous releases revelled in the slow depressing gloominess of pure doom metal.

Without renouncing the doom subgenre entirely, *Manic Frustration* incorporates grunge elements, chugging grooves and the whole gamut of 70s influences. Hendrix and Cream weigh in alongside The Beatles and Black Sabbath and it's a testament to Trouble's ingenuity that they can meld all these creative influences into one flowing, mature sound. This album is significantly catchier, tighter and more accessible than the band's previous four releases. Despite this and the phenomenal capacity for metal greatness evident on *Manic Frustration*, sales for this album were dismal and Trouble were subsequently dropped from the Def American label. Hang your heads America.

And then some:
- Singer Dave Wagner appeared on Dave Grohl's heavy metal side project Probot in 2004.
- Guitarist Bruce Franklin appeared on Christian thrash band Tourniquet's 2005 album *Where Moth and Rust Destroy*. Tourniquet features Trouble's ex-drummer Ted Kirkpatrick who played on the *Run to the Light* tour in 1989.
- Bruce Franklin and Rick Wartell are the only members of Trouble who have been with the band consistently since 1984.

TROUBLE
MANIC FRUSTRATION

Also by Trouble:
Psalm 9 (1984, originally self-titled) was the album that started it all for Trouble, and proved them to be key players in the post 70s doom metal scene alongside Candlemass.

TYPE O NEGATIVE
OCTOBER RUST
1996

In the movie The Usual Suspects, Kevin Spacey says, "The greatest trick the Devil ever pulled was convincing the world he didn't exist". Devotees of Brooklyn quintet Type O Negative will tell you the greatest trick they ever pulled was convincing the world they were completely serious. Humour is traditionally not something that the metal community does very well (Adult Swim's *Metalocalypse* is an obvious exception), but Type O Negative's fourth album *October Rust* has it in spades – think sex, death, love and suicide with go-go dancers and balloon animals.

After a bit tooling around, the album kicks off with *Love You to Death*, which (along with *Burnt Flowers Fallen*) is one of the less tongue-in-cheek and more impressive tracks on this album. The standout track however, is the 10-minute doom epic *Haunted* in which Peter Steele displays the titanic power and depth of his vocal range. Sonically the ultra-heavy low end combined with floating, atmospheric keyboards and Sabbath inspired riffing make for a very rich, dark composition. The self-deprecating irony of *Red Water (Christmas Mourning)*, *My Girlfriend's Girlfriend*, and a cover version of Neil Young's *Cinnamon Girl* show that Type O Negative aren't afraid of having a laugh, especially at their own expense.

And then some:

• Peter Steele once appeared on *Jerry Springer* to talk about his experience with groupies, as well as posing nude in a 1995 edition of *Playgirl* magazine.

• The intro *Bad Ground* was recorded as a joke to make the listener think their speakers were not plugged in properly.

• In 2005 the band posted a photo of a tombstone bearing Peter Steele's name and the dates 1962-2005 which resulted in a wildfire of rumours. The prank was done in honour of their contract with new label, SPV Records. See? Funny.

TYPE O NEGATIVE

OCTOBER RUST

Also by Type O Negative:
Slow, Deep and Hard (1991), *Bloody Kisses* (1993), and *Life is Killing Me* (2003) will turn you into a life-long Type-O-Negative fan.

UNEARTH
III: IN THE EYES OF FIRE
2006

How can one modest little portmanteau cause so much friction? Metalcore is (arguably) defined as the fusion of traditional heavy metal and hardcore punk with an emphasis on breakdowns. Some devout observers of subgenre regulations may balk at such a pedestrian explanation, demanding the subtle variations (metallic hardcore, melodic metalcore et al.) be given the appropriate recognition and deserved reverence. Some, like intellectual giant Dallas Coyle of God Forbid describe metalcore as "the poor man's choice for heavy aggressive music". Whatever your position in the metalcore debate, one name will always turn up in a conversation about awesomely heavy, skilfully executed melodic metal: Unearth.

In the Eyes of Fire is the ultimate metal album, however you classify it. You will bang your head, you will revel in the mastery of the musicians, you will rush out and by Unearth's previous release *The Oncoming Storm*. And so you should. The aptly titled sophomore release caused metal-loving fingertips to twitch with excitement as they cleared records from music store shelves. As such, the hype for Unearth's third studio album was immense and while many bands would have buckled under the pressure, the Massachusetts metal merchants stepped up to the plate with confidence. They knew their twin guitar attacks would flatten the competition, that the solid driving bass and Mike Justian's scorching fills would evoke tears of joy. Trevor Phipps vocals carry the weight of a hundred metal gods, thanks to Terry Date's outstanding (as ever) production on this album. Every single element required in the making of excellent metal is present right here, *In the Eyes of Fire*.

And then some:
- *Big Bear and the Hour of Chaos* was reportedly recorded in one hour while the band was drinking a brand of malt liquor called Big Bear.
- Unearth were originally called Point 04.
- One of Unearth's founding members Mike Rudberg once played a show at SXSW (South by Southwest) completely nude. He left the band days after the performance.

III: IN THE EYES OF FIRE

Also by Unearth:
Unearth have clearly gone for quality over quantity. You should pick up the rest of the catalogue: *The Stings of Conscience* (2001), *The Oncoming Storm* (2004) and *The March* (2008).

VAN HALEN

VAN HALEN

1978

When Van Halen descended from heaven in 1978, they simultaneously saved rock n roll and gave birth to heavy metal. Eddie Van Halen revolutionised the way people played guitar. David Lee Roth showed the world what it meant to be a frontman. Michael Anthony brought bass out of the shadows and Alex Van Halen proved that drumming can and should be creative. Though it may not be Van Halen's most technically accomplished album, their breakthrough effort tore the music world apart and, thankfully, it never quite regained it's disco friendly 4/4 time equilibrium.

"I live my life like there's no tomorrow". What an opening line for an album. These eight simple words (yes, one is a contraction) set the defiant tone for the entire album. In 1978, this was heavier than music had ever been. Black Sabbath, Led Zeppelin...no one could match Van Halen's balls-out brutality. *On Fire* and the tongue-in-cheek *Atomic Punk* were the toughest songs on radio and while they may not utilize the blastbeating death grunts of today's satanic standards, they remain timeless for their loud, fast, in-your-face approach. With track after track of delicious immortal metal (*Eruption, Ain't Talking 'Bout Love*, need I go on?) Van Halen's debut effort is one of the few albums to reach diamond status. What's that? You thought the scale stopped at platinum? As usual, Van Halen broke the mould. If you're a Roth-era devotee, if you're any variety of metal fan, if you have ears: Get. This. Now.

And then some:
- The guitar pictured on the album cover is said to be Eddie Van Halen's first ever 12-string.
- Bassist Michael Anthony was replaced in 2006 with Wolfgang Van Halen –Eddie Van Halen's son.
- When the Van Halen brothers first began playing instruments, Eddie took up drums and Alex played guitar. As the story goes, Alex would secretly play Eddie's drums when he wasn't home. Upon catching his brother in the act, Eddie exacted his revenge by playing Alex's guitar. Thus began one of the greatest partnerships in music history.

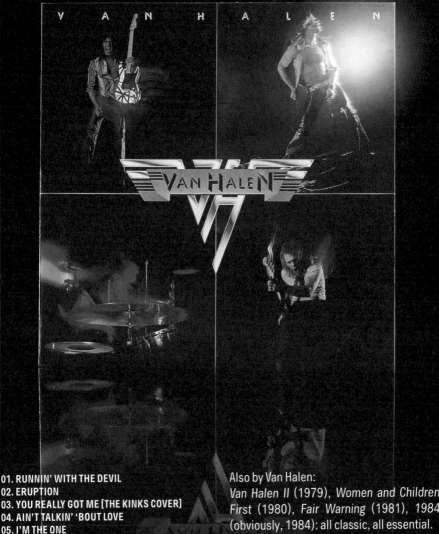

01. RUNNIN' WITH THE DEVIL
02. ERUPTION
03. YOU REALLY GOT ME [THE KINKS COVER]
04. AIN'T TALKIN' 'BOUT LOVE
05. I'M THE ONE
06. JAMIE'S CRYIN
07. ATOMIC PUNK
08. FEEL YOUR LOVE TONIGHT
09. LITTLE DREAMER
10. ICE CREAM MAN [JOHN BRIM COVER]
11. ON FIRE

Also by Van Halen:
Van Halen II (1979), Women and Children First (1980), Fair Warning (1981), 1984 (obviously, 1984): all classic, all essential.

VENOM

BLACK METAL

1982

If one were to give a list of the most influential metal albums to the average punter on the street, chances are they would recognise most of the names on the list. Black Sabbath's eponymous debut, Metallica's Master of Puppets, Slayer's Reign in Blood, and Iron Maiden's The Number of the Beast would all ring a bell. However, Venom's 1982 sophomore release would have more than a few people scratching their heads.

Despite helping spawn a sub-genre of the same name, Black Metal has more in common musically with early hardcore punk bands such as Black Flag, Minor Threat and Bad Brains than the likes of Darkthrone, Emperor and Mayhem. Venom took the speed and aggression of hardcore punk, and added a dark, theatrical and ironic twist. There's nothing flashy or epic about Black Metal, the songs are short and simple, the lyrics cheesy, the production sub-par –but that's what makes it such a necessary addition to any metal collection. Upon its release, Black Metal delivered a raw, chaotic ode to loud noise unlike anything heard before. Even Motörhead raised a collective perturbed eyebrow. Standout tracks on this album are the title track, To Hell and Back, and the fist pumping, double kick driven, Countess Bathory. The importance of Black Metal (and 1981's Welcome to Hell) cannot be underestimated, or indeed measured, as it helped shaped hundreds of bands across myriad sub-genres over the next two and a half decades.

And then some:

• Henry Rollins once described Venom's live show as "like seeing Spinal Tap…I expected them to go into Sex Farm at any second", to which Venom responded "Henry didn't have the balls to speak to us back then, he hid backstage, but now he mouths off behind our backs. His band were useless and that's why he writes books now".

• Vocalist and bassist Conrad "Cronos" Lant said that Venom's adoption of evil imagery and subject matter was inspired by the likes of Ozzy Osbourne who would "sing about evil things and dark figures, then spoil it all by going 'Oh no, no please God, help me!'".

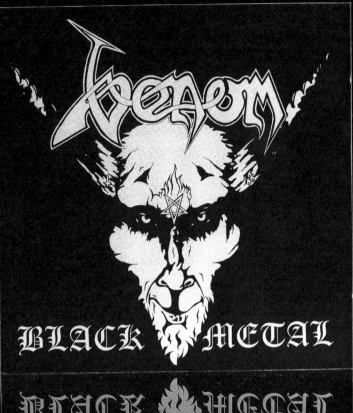

BLACK METAL

Also by Venom:
Welcome to Hell (1981), *At War with Satan* (1984), and 2008's *Hell* are entertaining to say the least.

W.A.S.P.

W.A.S.P.
1984

As the son of a preacher man and grandson of a deacon, little Blackie Lawless could have gone either way. Though it was probably a far stretch to believe his fundamentalist Christian upbringing would produce a pious god-fearing do-gooder (such things are surely determined from birth), I don't think anyone expected Blackie to turn out quite like this. As frontman for 80s glam metal band W.A.S.P, Blackie did his best to become the devil incarnate: king of the cod-piece and purveyor of perverted stage antics. W.A.S.P became known for their live shows which incorporated "torturing" half naked women, hurling animal blood and feathers into the crowd and of course, Lawless "penetrating" various effigies with strap-on knives.

Needless to say, W.A.S.P were on the fringe of the 80s glam scene. They were darker, heavier and far less glamorous than their contemporaries. There was no glitter or effeminate makeup, no happy shiny choruses or helium-high vocals. Their self-titled debut offered a harder alternative to metal fans along the lines of Mötley Crüe and Ratt. W.A.S.P is 38 minutes of mammoth metal anthems, kicking off with I Wanna Be Somebody which made VH1's recent list of top 100 hard rock songs. L.O.V.E Machine, School Daze, The Flame, Hellion...there are no bad tracks here. If your mum was cool enough to let you get the 1998 reissue, your album will open with Animal (I Fuck Like A Beast). Tipper Gore put it at number 9 on her "filthy 15" list. That alone should have you handing over your cash.

And then some:
- Blackie Lawless was once injured during a live show after his spark-firing cod-piece malfunctioned.
- *Hellion* was covered by Children of Bodom on their 2000 album *Follow the Reaper*.
- Blackie Lawless was born Steven Edward Duren.

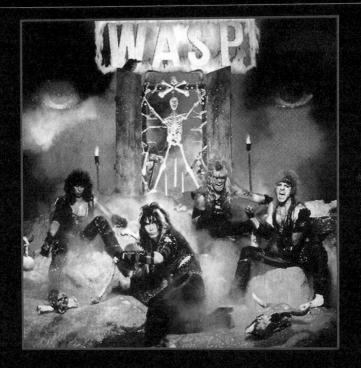

1. I WANNA BE SOMEBODY
2. L.O.V.E. MACHINE
3. THE FLAME
4. B.A.D.
5. SCHOOL DAZE
6. HELLION
7. SLEEPING (IN THE FIRE)
8. ON YOUR KNEES
9. TORMENTOR
10. TORTURE NEVER STOPS

Also by WASP:
The Headless Children (1989) and *The Crimson Idol* (1992) are just as loud, obnoxious and fun.

WHITE ZOMBIE

ASTRO CREEP: 2000 –SONGS OF LOVE, DESTRUCTION AND OTHER SYNTHETIC DELUSIONS OF THE ELECTRIC HEAD
1995

White Zombie didn't so much burst onto the scene as slink out of the shadows. They'd been there, toiling away since 1987, developing their sound shaped by various line-up changes and external influences. A leg-up from Geffen in 1992 produced *La Sexorcisto: Devil Music Vol.1*, White Zombie's first commercial success. Critics took note, fans gathered round and teenage boys everywhere had Sean Yseult posters strategically placed on their bedroom ceilings. The faint drum roll of White Zombie's early career was almost deafening by the time *Astro Creep: 2000* dropped in 1995. And no one was disappointed.

With an altogether darker and more disturbing feel, *Astro Creep: 2000* tapped into the musical cravings of 1995: grunge was dying a slow agonising death and metal was in need of something...else. White Zombie's SoCal "mainstream" leanings made the dark side accessible to the Cobain-cardigan set and tested the boundaries of heavy music. *Astro Creep: 2000* is a 52-minute ghost-ride of musical experimentation, fusing B-grade horror movie samples with down tuned guitars, fierce grooves and thrash sensibilities. A bigger budget, more time and the technical wizardry of John Tempesta, made White Zombie's fourth and final release a memorable one. Standout tracks include the creepy *Grease Paint and Monkey Brains*, the groove-laden *Blood Milk and Sky* and of course, the Grammy nominated *More Human Than Human*.

And then some:
- *More Human Than Human* won MTV's Video Music Award for Best Rock Video.
- Sean Yseult is now an artist and fashion designer.
- Rob Zombie went on to become a successful film director specialising in horror movies and music videos (he directed the video for Ozzy Osbourne's *Dreamer*).

ASTRO-CREEP: 2000

STEREOPHONIC SPACE SOUND

WHITE ZOMBIE

Also by White Zombie:
La Sexorcisto: Devil Music Vol. 1 (1992)
is a decent prelude to Astro Creep: 2000.

YNGWIE MALMSTEEN
RISING FORCE
1984

In the late 18th to mid 19th centuries, there lived a virtuoso violinist named Niccolo Paganini. Paganini's extraordinarily long fingers could span three octaves across four strings with astonishing speed and accuracy –a feat largely considered impossible by both the past and present day musical elite. It was rumoured that Paganini had sold his soul to the Devil to achieve such unattainable heights of musical wizardry. More than 160 years after his death, but one man has raised his Viking fist to claim Paganini-esque talent. Such a declaration denotes an unassailable self-confidence, a gargantuan ego and yes, the talent to back it up. All hail Yngwie Malmsteen, the greatest neoclassical six string slinger alive today (move over Eddie Van Halen).

Rising Force is Malmsteen's debut solo album. Its release in 1984 caused a widespread slackening of jaws among fans and critics alike. The clunking sound of guitars hitting cement floors could be heard in garages across the globe as aspiring young musicians threw up their hands in defeat. What was the point? Malmsteen plays his guitar like a classical violinist incorporating minor scales and phrasing, wide vibrato and blindingly fast picking techniques. Six of *Rising Force*'s eight tracks are instrumentals. If it were any other artist, such an album would be considered intolerably unbalanced if not boring. Malmsteen doesn't do boring. He does extravagance. If this savant sold his soul, he did it for heavy metal.

And then some:
• *Rising Force* features Barriemore Barlow (of Jethro Tull) on drums, Jens Johansson on Keyboards and Jeff Scott Soto on vocals (tracks 3 and 6).
• Malmsteen played all electric, acoustic and bass guitars on *Rising Force*.
• Yngwie J. Malmsteen was born Lars Johan Yngve Lannerbäck.
• Malmsteen started his first band, Track on Earth at the age of 10.

Yngwie J. Malmsteen's
Rising Force

825 324-2

Also by Yngwie Malmsteen:
Trilogy (1986) is yet another bold display of epic shredding from this master technician.

t goes without saying that there are thousands of exceptional heavy metal albums from all eras, subgenres and classifications. Painful, heartbreaking cuts had to be made in order to whittle this list down to a mere 100. What follows is a list of some of the bands that were under consideration but didn't make it through the culling process for whatever reason. Plenty more bands could be added here, countless albums could have made the cut—there will never be a unanimous list.

Honourable Mentions:

Aerosmith; All that Remains; Amon Amarth; Arsis; Audioslave; Autopsy; Baroness; Bathory; Between the Buried and Me; Black Dahlia Murder; Blind Guardian; Body Count; Celtic Frost; Children of Bodom; Clutch; The Cult; D.A.D; Darkest Hour; Def Leppard; Every Time I Die; Faith No More; Gary Moore; The Hellacopters; Iced Earth; Job for a Cowboy; King Crimson; Kyuss; Led Zeppelin; Manowar; Marduk; Ministry; Nile; Queens of the Stone Age; Quiet Riot; Running Wild; Scorpions; Skinless; Soil; Soilwork; Soundgarden; Suicidal Tendencies; The Red Chord; Thin Lizzy; Twisted Sister; Uriah Heep; Volbeat; Whitesnake.